The DEPRESSION GLASS Collector's Price Guide

The DEPRESSION GLASS Collector's Price Guide

by Marian Klamkin

photographs by Charles Klamkin

HAWTHORN BOOKS, INC.
PUBLISHERS/*New York*

THE DEPRESSION GLASS COLLECTOR'S PRICE GUIDE

Library of Congress Catalog Card Number: 74-6663

ISBN: 0-8015-2018-5

1 2 3 4 5 6 7 8 9 10

Contents

Introduction

This price guide is designed as a supplement to The Collector's Guide to Depression Glass, to be used as a separate take-along book and handy reference when shopping for glassware of the depression era. It should also be helpful to those who sell the glassware at the many exciting shows held throughout the year. While written with the beginning collector in mind, it has also been planned to be especially helpful to advanced collectors who specialize in various kinds of depression glassware.

In listing the major dinnerware and luncheon patterns, I have separated the pieces so that the dinner or luncheon plates, which were made in some quantity, are listed first. These are followed by the bowls, cups, saucers, smaller plates, and other pieces that make up place settings. The serving pieces are listed next as an aid to the specialist-collectors, who search only for a variety of butter dishes, cookie jars, candy jars, or other important pieces. In a section called adjunctive pieces, I have listed shapes that were not considered tableware made in each pattern. In addition, there are separate listings of kitchenware, punch sets, barware, and advertising items.

Previous literature on the subject of depression glass has included the better glassware made at the same time by Fostoria, Westmoreland, Smith, and other glass firms. This becomes confusing to true depression glass collectors, since many of the better pieces are not the totally machine-made glassware for which they are searching. In order to avoid this confusion I have left these better patterns and odd pieces out of this book. A careful reading of The Collector's Guide to Depression Glass will give the new collector a clear idea of what he should look for, who made it, and the characteristics of the glass in the true "depression" category.

At no time in American history has a hobby become so popular in such a short time as the collecting of depression glass. New clubs are being formed continually where enthusiastic hobbyists can share information with each other. Depression glass collecting promises to become a true "grass roots" pursuit for young and old across the nation. This Depression Glass Collector's Price Guide is offered to further interest in this fascinating hobby.

A Word about Depression Glass Prices

It should come as no surprise to depression glass collectors that prices for favorite patterns and colors have risen sharply. With the publication of The Collector's Guide to Depression Glass and the publicity that it generated, more and more glass collectors are beginning to specialize in the colored glassware of the 1920s, 1930s, and 1940s. It has become increasingly difficult to find all the known pieces in a single color and pattern--and the serving pieces are especially difficult to locate. Ask any butter dish collector!

The prices quoted in this guide are composites of those current in the West, the Midwest, the South, and the East. Prices are generally highest on the West Coast where there have been many avid collectors for some years. The hobby is just catching on in the East, especially in the New England area, and bargains can still be found there. In no case is any price given here a firm one. There are too many variables, and prices quoted are meant only as a guide in determining what a given piece of glass is worth. The hobby has grown so fast that there are not, as in other collecting areas, established auction prices that can be applied.

New and as yet unrecorded pieces, colors, and patterns will continue to be discovered for many years to come. This is one of the things that makes this particular collecting hobby so exciting. It will be awhile before all the products of the prolific American glass companies of the 1920s, 1930s, and 1940s can be sorted out, documented, and the prices stabilized. One way to keep abreast of current trends and new discoveries is to subscribe to the excellent journals now being published on depression glass. Two outstanding and helpful periodicals are Depression Glass Daze and National Depression Glass Journal.

Use this book as a guide rather than a bible. As all collectors know, supply and demand is still the rule in shopping for anything old and collectible. The prices given here are the present national average trend and are certainly not meant to be firm. These are retail prices, and dealers should be aware that their prices should be from 40 percent to 50 percent lower. Both dealers and collectors know that bargains can still be found in goodwill shops, flea markets, and church bazaars. All prices given are for perfect pieces only. Beware of current reproductions and check Depression Glass Daze and National Depression Glass Journal carefully to see what glass currently is being made with the intention of passing it off to unsuspecting novice collectors.

Keep in mind that as more and more depression glass comes on the collectors' market, old pieces, in as yet undiscovered colors, will turn up and some of the smaller sets of glassware will be found to have more pieces than had been thought previously. Expect serving pieces to keep going up in price, since there is so much competition for them. In addition, patterns particularly representative of the Art Deco style are now being sought by collectors who do not necessarily specialize in glass.

Collecting depression glass is an enjoyable hobby and has already proved to be a worthwhile investment. Take this <u>Depression Glass Collector's Price Guide</u> with you whenever you go out to shop. Success and happy hunting!

The
DEPRESSION
GLASS
Collector's Price
Guide

Section I
Dinnerware and Luncheon Patterns

ADAM

Individual pieces	Pink	Green	Crystal
Plate, dinner, 9"	$3.50	$4.50	$2.50
Plate, grill, 9"	3.00	3.50	2.50
Plate, salad, 7 3/4"	2.00	2.50	1.50
Plate, sherbet, 6"	2.00	2.50	
Bowl, 7 3/4"	5.00	6.00	
Bowl, 5 3/4"	2.50	3.50	
Bowl, 4 3/4"	2.50	3.00	1.50
Cup	4.50	5.50	4.00
Saucer	2.00	2.50	2.00
Tumbler, conical, 9 oz.	7.00	8.50	
Tumbler, conical, 7 oz.	6.00	7.00	5.00
Sherbet	3.50	4.00	
Coaster	2.50	3.50	

Serving pieces			
Bowl, oval vegetable, 10"	7.00	8.00	
Bowl, covered vegetable, 9"	12.50	14.00	
Bowl, 9"	6.00	7.50	6.00
Platter, 12"	5.00	7.00	
Cake plate, 10"	8.00	10.00	
Relish dish (two part), 8"	5.00	6.00	
Sugar bowl and cover	4.50	5.50	
Creamer	3.50	4.50	
Pitcher, conical, 32 oz.	12.50	17.50	10.00
Salt and pepper, 4"	15.00	20.00	
Spice shakers (pair), 6"	17.50	20.00	

-1-

Serving pieces (Cont.)	Pink	Green	Crystal
Butter dish and cover	$25.00	$50.00	
Candy jar and cover	17.50	20.00	

Adjunctive pieces

	Pink	Green	Crystal
Candlesticks (pair), 3 7/8"	20.00	25.00	
Ash tray, 4 1/2"	3.50	4.50	$2.50
Vase, 7 1/2"	10.50	14.00	

 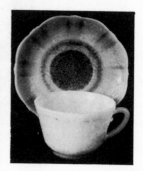

AMERICAN SWEETHEART

Individual pieces	Pink	Monax, Cremax	Ritz Blue, Ruby Red
Plate, dinner, 10"	$4.00	$8.00	
Plate, 9"	3.00	6.00	
Plate, 8"	2.00	5.00	$70.00
Bowl (rimmed), 10"	4.50	9.00	
Bowl, 6"	3.00	6.00	
Bowl, 4 1/2"	5.00	10.50	
Bowl, 3 1/2"	4.00	8.00	
Cup	3.50	5.00	75.00
Saucer	2.00	3.50	30.00
Tumbler, 10 oz.	10.00		
Tumbler, 9 oz.	9.00		
Tumbler, 5 oz.	8.00		
Sherbet, 4"	4.00	7.50	
Sherbet (metal base) crystal only, $5.00			

Serving pieces	Pink	Monax, Cremax	Ritz Blue, Ruby Red
Bowl, oval, 10"	$7.50	$20.00	
Bowl, 9"	7.50	20.00	
Plate, 15 1/2"		70.00	$250.00
Plate, 12"	6.00	10.00	125.00
Plate, 11"	5.00	7.00	
Platter, 13"	7.00	20.00	
Tidbit set, 2-tier (12", 8" plates)	20.00	25.00	125.00
Tidbit set, 3-tier (15 1/2", 12", 8" plates)			150.00
Tidbit set, 3-tier (10 1/4", 9", 8" plates)			275.00
Lazy Susan, metal stand (15 1/2" plate)		75.00	
Sugar bowl (cover only on Monax)	3.50	75.00	75.00
Creamer	3.50	4.50	75.00
Pitcher, 60 oz., 7 1/2"	125.00		
Pitcher, 56 oz., 7"	100.00		
Salt and pepper	50.00	50.00	

Adjunctive piece

Console bowl, 18"		125.00	750.00

ANNIVERSARY

Individual pieces	Pink
Plate, 9"	$2.50
Plate, 6 1/4"	1.50
Bowl, 5"	2.00
Bowl, 8"	2.00
Cup	3.00
Saucer	2.50
Wineglass, 2 1/2 oz.	3.00
Sherbet	2.50

Serving pieces	
Bowl, 9"	5.00
Plate, 12 1/2"	6.00
Plate, cake, 12 1/2"	6.00
Relish dish, 8"	5.00
Pickle dish, 9"	4.50
Comport	2.50
Sugar and cover	3.50
Creamer	2.50
Butter dish and cover	30.00
Candy jar and cover	7.50

Adjunctive pieces	
Vase, 6 1/2"	7.50
Vase, pinup for wall	7.50

BLOCK

Individual pieces	Pink, Crystal, Green	Topaz
Plate, 9"	$2.50	$3.50
Plate, grill, 9"	2.00	
Plate, 8"	1.75	2.50
Plate, 6"	1.50	2.00
Bowl, 7"	2.50	4.00
Bowl, 5 1/4"	2.00	2.50
Bowl, 4 1/4"	1.00	1.75
Cup (2 designs)	2.00	3.00
Saucer	1.50	2.25
Tumbler, 10 oz.	4.50	5.00
Tumbler, 9 oz.	3.00	3.00
Tumbler, 5 oz.	2.00	2.50
Whiskey glass	2.00	2.50
Tumbler, footed, 10 oz.	4.00	6.00
Tumbler, footed, 9 oz.	3.50	5.00
Tumbler, footed, 5 oz.	3.00	4.00
Goblet, 7 1/4"	8.00	
Goblet, 6"	7.00	9.00
Goblet, 4 1/2"	5.50	6.50
Goblet, 4"	5.00	6.00
Sherbet, round	2.50	3.00
Sherbet, conical	2.50	3.00
Sherbet, stemmed, 5"	5.50	7.50

Serving pieces		
Bowl, 8 3/4"	4.50	5.50
Plate, 10"	4.00	6.00
Sandwich server, center post	8.00	10.50
Butter dish with cover, oblong	10.00	17.50
Butter dish with cover, round	20.00	35.00

Serving pieces (Cont.)	Pink, Crystal, Green	Topaz
Candy jar with cover, 6 1/2"	$10.00	$20.00
Candy jar with cover, 2 1/4"	7.50	15.00
Sugar bowl, conical	2.50	3.50
Sugar bowl, round, footed	2.50	3.50
Sugar bowl, straight-sided	2.50	3.50
Creamer, conical	2.50	3.50
Creamer, round, footed	2.50	3.50
Creamer, straight-sided	2.50	3.50
Salt and pepper	7.50	10.00

Adjunctive pieces

Ice bucket, bail handle	7.50	12.50
Ice tub	6.50	10.00
Orange reamer	3.00	5.00
Water decanter with glass	7.50	12.50
Candlesticks (pair), 1 3/4"	10.00	12.50

BUBBLE

Individual pieces	Pink	Crystal, Dark Green, Light Blue	Ruby Red
Plate, 9 1/4"		$1.75	$5.00
Plate, grill, 9 1/4"		1.50	
Plate, 6 3/4"		1.00	
Bowl, 7 3/4"		2.50	
Bowl, 5 1/4"		1.50	
Bowl, 4 1/2"		1.00	3.00
Bowl, 4"		1.00	
Cup		2.00	4.00
Saucer		1.00	3.00

Individual pieces (Cont.)	Pink	Crystal, Dark Green, Light Blue	Ruby Red
Tumbler, 16 oz.			$5.00
Tumbler, 12 oz.			4.00
Tumbler, 9 oz.			3.50
Tumbler, 6 oz.			3.00

Serving pieces

	Pink	Crystal, Dark Green, Light Blue	Ruby Red
Bowl, 8 3/8"	$4.50	$4.00	6.50
Platter, 12"		4.00	6.50
Sugar		3.50	
Creamer		3.50	
Pitcher, ice lip, 64 oz.			15.00

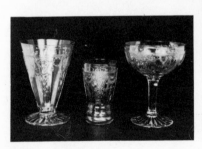
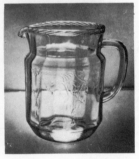

CAMEO

Individual pieces	Green	Topaz	Pink
Plate, grill, 10 1/2"	$3.00	$2.50	
Plate, 9 1/2"	5.00	4.00	

Individual pieces (Cont.)	Green	Topaz	Pink
Plate, 8"	$3.00	$2.50	$8.00
Plate, square, 8"	6.00		
Plate, 6"	2.50	2.00	6.00
Bowl, rimmed, 9"	7.50		
Bowl, 7"	5.00	5.00	
Bowl, 5 1/2"	3.50	4.50	
Bowl, 4 3/4"	5.00		
Cup (2 styles)	4.00	3.00	10.00
Saucer, depressed ring	7.50		
Saucer, no ring	2.50	2.00	5.50
Tumbler, footed, 11 oz.	10.00		
Tumbler, footed, 9 oz.	8.00	8.00	
Tumbler, footed, 3 oz.	12.50		
Tumbler, 14 oz.	10.00		
Tumbler, 11 oz.	10.00		
Tumbler, 10 oz.	10.00	10.00	
Tumbler, 9 oz.	5.50		12.50
Tumbler, 5 oz.	8.50		12.50
Sherbet, high-stemmed, 5"	7.50	8.00	17.50
Sherbet, 3"	3.50	4.50	7.50
Goblet, 6"	15.00		15.00
Goblet, 4"	17.50		17.50

Serving pieces

	Green	Topaz	Pink
Bowl, 8 1/4"	6.50		
Bowl, oval, 9"	6.50		
Plate, 10"	5.00		
Plate, 10 1/2"	4.50		
Platter, 10 1/2"	6.00		
Cake plate, with legs, 10"	10.00		
Relish dish, round, 3-part	5.50		20.00
Butter dish and cover	40.00		
Cookie jar and cover	12.50		
Candy dish and cover, 6 1/2"	25.00		
Candy dish and cover, 4"	20.00	25.00	
Comport, conical, 4"	6.50		
Pitcher, 56 oz.	17.50		
Pitcher, 36 oz.	15.00		
Sugar bowl, 2 sizes	3.00	3.50	
Creamer, 2 sizes	3.00	3.50	
Salt and pepper, 4"	20.00		35.00

Adjunctive pieces

	Green		
Water bottle and stopper, 8 1/2"	20.00		
Water bottle and stopper, frosted	14.00		

-8-

Adjunctive pieces (Cont.)	Green	Topaz	Pink
Water bottle, "Whitehouse vinegar" embossed (see Advertising Items)			
Ice bowl, 3 1/2"	$75.00		$60.00
Jar and cover, 2"	35.00		
Candlesticks (pair), 4"	25.00		
Vase, 8 1/2"	10.00		
Vase, 5 3/4"			

CHERRY BLOSSOM*

Individual pieces	Pink	Green	Delfite
Plate	$3.50	$5.00	$12.50
Plate, grill, 9"	4.00	4.00	
Plate, 7"	4.00	4.00	
Plate, 6"	2.00	2.50	3.50
Bowl, soup, 7 3/4"	10.00	15.00	
Bowl, 5 3/4"	4.00	5.00	10.00
Bowl, 4 3/4"	3.00	2.75	5.00
Cup	5.50	6.00	12.50
Saucer	2.00	2.00	5.00
Tumbler, footed, 9 oz.	7.50	6.50	15.00
Tumbler, footed, 4 oz.	5.00	5.00	12.50
Tumbler, 12 oz.	5.50	5.50	
Tumbler, 9 oz.	5.00	5.00	
Tumbler, 5 oz.	4.50	5.00	
Sherbet	4.00	5.00	12.50
Mug, 8 oz.	35.00	40.00	
Coaster	3.00	4.00	

*See color plates 4 and 10 in The Collector's Guide to Depression Glass.

Serving pieces	Pink	Green	Delfite
Bowl, fruit, 3-legged, 10 1/2"	$13.50	$17.50	
Bowl, handled, 9"	7.50	8.00	$12.50
Bowl, oval, 9"	6.00	7.50	17.50
Bowl, 8 1/2"	6.00	7.50	15.00
Platter, 13"	12.50	15.00	
Platter, divided, 13"	12.50	15.00	
Platter, 11"	6.00	7.50	25.00
Sandwich tray, 10 1/2"	6.50	8.00	12.50
Cake plate, 10 1/4"	7.00	8.50	
Butter dish and cover	30.00	40.00	
Pitcher, 42 oz.	17.50	20.00	
Pitcher, conical, 36 oz.	17.50	20.00	
Pitcher, 36 oz.	16.50	18.50	75.00
Sugar and cover (no cover in Delfite)	5.00	5.50	17.50
Creamer	4.00	5.00	17.50
Salt and pepper (round foot, scalloped foot)	125.00	125.00	

Jeannette Junior Dinner Set	Pink		Delfite
Plate, 6"	$7.50		$10.00
Cup	15.00		17.50
Saucer	6.50		7.50
Sugar	22.50		25.00
Creamer	22.50		25.00
Set of 14 pieces	150.00		165.00
Set in original box	160.00		175.00

CLOVERLEAF

Individual pieces	Crystal, Pink, Green	Topaz	Black
Plate, grill, 10"	$3.50		
Plate, 9"	3.50		
Plate, 8"	2.50	$4.00	$6.50
Plate, 6"	2.50	3.00	5.00
Bowl, 7"	5.50	8.00	
Bowl, 6 3/4"	2.00	3.50	
Bowl, 5"	1.75	3.00	
Bowl, 4"	1.75	3.00	
Cup	3.00	4.00	5.00
Saucer	1.75	2.50	3.50
Tumbler, footed, 10 oz.	5.00	7.50	
Tumbler, 10 oz.	4.50	6.50	
Tumbler, 9 oz.	4.00	5.00	
Sherbet	2.00	3.00	6.50

Serving pieces			
Bowl, oval, 9"	7.50	10.50	
Bowl, 8"	6.00	10.00	
Candy dish and cover	17.50	22.50	
Sugar	4.00	6.00	7.00
Creamer	4.00	6.00	7.00
Salt and pepper	15.00	22.50	25.00
Ash tray, 5 3/4"			7.50
Ash tray, 4"			7.00

COLONIAL*

Individual pieces	Pink, Green	Crystal
Plate, 10"	$5.50	$3.50
Plate, grill, 10"	4.00	3.00
Plate, 8 1/2"	3.50	2.50
Plate, 6 1/2"	2.50	2.00
Bowl, soup, 7"	4.00	3.00
Bowl, 5 1/2"	2.75	2.00
Bowl, 4 1/2"	2.75	2.00
Bowl, cream soup, 4 1/2"	2.75	2.00
Cup	4.00	3.00
Saucer	3.00	2.00
Tumbler, footed, 10 oz.	6.25	5.25
Tumbler, footed, 5 oz.	5.50	4.00
Tumbler, footed, 3 oz.	5.50	4.00
Tumbler, 15 oz.	5.50	4.00
Tumbler, 12 oz.	5.50	4.00
Tumbler, 10 oz.	5.50	4.00
Tumbler, 9 oz.	5.50	4.00
Tumbler, 5 oz.	4.50	3.50
Whiskey glass, 1 1/2 oz.	4.00	3.00
Goblet, 8 1/2 oz.	7.50	6.50
Goblet, 4 oz.	5.00	4.00
Goblet, 3 oz.	5.50	3.50
Goblet, 2 1/2 oz.	5.50	3.50
Goblet, 2 1/2 oz.	5.50	3.50
Sherbet	4.00	3.00

*See color plate 9 in The Collector's Guide to Depression Glass.

Serving pieces	Pink, Green	Crystal
Bowl, oval, 10"	$7.00	$6.00
Bowl, 9"	7.00	6.00
Platter, 12"	7.00	6.00
Sugar and cover	7.50	5.50
Creamer	6.50	4.50
Pitcher, 67 oz.	27.50	17.50
Pitcher, 54 oz.	17.50	15.00
Butter dish and cover	35.00	25.00
Salt and pepper	17.50	12.50

Adjunctive piece

Spoon holder, 5 1/2"	12.50	10.00

COLONIAL FLUTED (ROPE)

Individual pieces	Pink	Green
Plate, 8"	$1.50	$1.25
Plate, 6"	1.25	1.00
Bowl, 6"	1.50	1.25
Bowl, 4"	1.50	1.25
Cup	2.50	2.00
Saucer	1.50	1.50

Serving pieces		
Bowl, 7 1/2"	4.50	3.50
Bowl, 6 1/2"	3.50	3.00
Sugar and cover	4.50	4.00
Creamer	3.50	3.00

COLUMBIA

Individual pieces	Pink	Crystal
Plate, 9 1/2"	$2.50	$2.00
Plate, 6"	1.50	1.00
Bowl, soup, 8"	2.00	1.50
Bowl, 5"	2.00	1.50
Cup	3.00	2.00
Saucer	2.00	1.00

Serving pieces		
Plate, 11 3/4"	4.00	3.00
Bowl, ruffled edge, 10 1/2"	5.00	3.50
Bowl, 8 1/2"	3.00	2.00
Butter dish and cover	15.00	12.50
Butter dish with metal cover		10.00

Adjunctive piece		
Hurricane lamps (pair)	10.00	8.00

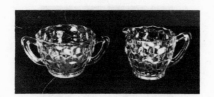

CUBIST

Individual pieces	Green	Pink	Crystal
Plate, 8"	$3.50	$3.00	$1.50
Plate, 6"	2.50	2.00	1.50
Bowl, 6 1/2"	4.00	3.00	2.00
Bowl, 4 1/2"	2.50	2.00	1.50
Bowl, deep, 4 1/2"	2.50	2.00	1.50
Cup	5.00	4.00	3.00
Saucer	3.50	3.00	2.50
Tumbler, 9 oz.	5.50	4.50	3.50
Sherbet	3.00	2.50	2.00
Coaster	2.50	2.00	2.00

Serving pieces			
Tray with handles, 7 1/2"	3.00	2.75	2.00
Sugar and cover, 3"	5.00	5.00	3.50
Creamer, 3"	4.00	4.00	3.00
Sugar, 2"	2.50	2.50	2.00
Creamer, 2"	2.50	2.50	2.00
Butter dish and cover	25.00	25.00	20.00
Candy jar and cover	12.50	12.50	10.00
Salt and pepper	15.00	15.00	12.50
Pitcher, 8 3/4"	47.50	45.00	40.00

Adjunctive piece			
Powder jar and cover	10.00	8.50	7.50

DAISY (ORCHARD)

Individual pieces	Crystal	Amber
Plate, 9 1/2"	$4.00	$4.00
Plate, grill, 10 1/4"	3.00	3.00
Plate, 8 1/2"	2.50	2.50
Plate, 7 1/2"	2.00	2.00
Plate, 6"	1.50	1.50
Bowl, 6"	2.00	2.00
Bowl, cream soup, 4 1/2"	2.00	3.00
Bowl, 4 1/2"	1.50	2.50
Cup	2.00	3.50
Saucer	1.50	2.00
Tumbler, 12 oz.	2.50	6.00
Tumbler, 9 oz.	2.00	5.50
Sherbet	2.00	3.00

Serving pieces		
Plate, 11 1/2"	3.00	5.00
Plate, 10 3/4"	2.00	6.50
Platter, 10 3/4"	3.00	7.50
Relish dish, 3-part, 8 1/2"	3.00	5.50
Sugar	2.50	4.50
Creamer	2.50	4.50

 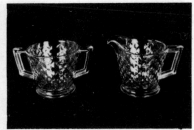

DIAMOND QUILTED

Individual pieces	Blue, Pink, Green, Crystal
Plate, 8"	$3.00
Plate, 7"	2.00
Plate, 6"	1.50
Bowl, 5"	1.50
Bowl, handles, 4 3/4"	4.50
Cup	3.50
Saucer	2.00
Tumbler, footed, 12 oz.	5.00
Tumbler, footed, 8 oz.	4.50
Tumbler, footed, 6 oz.	4.00
Tumbler, blown, 12 oz.	5.00
Tumbler, blown, 9 oz.	4.00
Goblet, 9 oz.	7.50
Goblet, 3 oz.	6.50
Goblet, 2 oz.	5.50
Goblet, 1 oz.	4.50
Sherbet	3.00

Serving pieces	
Plate, 14"	7.50
Bowl, crimped edge, 7"	4.00
Bowl, handled, 5 1/2"	3.50
Candy jar and cover	12.50
Covered dish, 3-legged, 6 1/4"	7.50
Pitcher, 1/2 gal.	12.50
Sugar	3.00
Creamer	3.00
Mayonnaise set (3 pieces)	7.50

Adjunctive piece	
Candlesticks (pair)	10.00

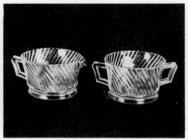

DIANA

Individual pieces	Amber	Crystal	Pink
Plate, 9 1/2"	$4.00	$3.00	$3.50
Plate, 6"	3.00	2.50	3.50
Bowl, cream soup, 5 1/2"	3.50	3.00	3.50
Bowl, 5"	2.50	2.00	2.50
Cup	3.50	2.50	3.50
Saucer	2.50	2.00	2.50
Tumbler, 9 oz.	6.50	5.00	6.00
Sherbet	4.00	3.00	4.00
Coaster	2.50	2.00	2.50

Serving pieces			
Plate, 11 3/4"	7.50	6.00	7.50
Platter, 12"	6.50	5.00	6.50
Bowl, scalloped edge, 12"	8.00	6.00	8.00
Bowl, 11"	6.50	5.00	6.50
Candy jar and cover	10.00	7.50	10.00
Sugar	4.50	3.50	4.50
Creamer	4.50	3.50	4.50
Salt and pepper	15.00	12.50	15.00

Adjunctive piece			
Ash tray	3.00	2.00	3.00

Note: Demitasse set with metal rack, 6 cups, saucers, plates, not part of set, can be found in crystal, plain, or with metallic and colored trim, but pattern matches Diana. Price of complete set, $27.50.

DOGWOOD*

Individual pieces	Green	Pink	Crystal	Monax	Cremax
Plate, grill, 10 1/2" (pattern on rim only)	$3.50	$3.00	$3.00		
Plate, grill, 10 1/2" (allover pattern)	3.50	3.00	3.00		
Plate, 9 1/4"	5.00	3.50	3.50		
Plate, 8"	3.00	2.00	2.00		
Plate, 6"	2.50	1.75	1.75		
Bowl, 5 1/2"	4.00	3.00	3.00		
Tumbler, 13 oz. (silk-screen design)	17.50	12.50	12.50		
Tumbler, 10 oz. (silk-screen design)	15.00	10.50	10.50		
Tumbler, plain, 13 oz.	3.50	2.50	2.50		
Tumbler, plain, 10 oz.	3.00	2.00	2.00		
Cup (thin or thick glass)	5.00	3.50	3.50	$12.50	$12.50
Saucer	3.50	2.50	2.50	6.00	6.00
Sherbet	4.00	3.00	3.00		

Serving pieces	Green	Pink	Crystal	Monax	Cremax
Plate, 13"	27.50	22.50	22.50		
Plate, 12"	10.00	7.50	7.50	27.50	27.50
Platter, 12"	50.00	37.50	37.50		
Bowl, 8 1/2"	15.00	12.50	12.50	30.00	30.00
Bowl, 9 1/2"	17.50	14.50	14.50		
Pitcher (silk-screen design), 8"	112.50	40.00	40.00		
Pitcher, plain, 8"	10.00	9.00	9.00		
Pitcher (silk-screen design), 7 1/2"		85.00	85.00		

*See color plate 16 in <u>The Collector's Guide to Depression Glass</u>.

-19-

Serving pieces (Cont.)	Green	Pink	Crystal	Monax	Cremax
Tidbit set (metal post), 2-tier (12", 8" plates)	$40.00	$30.00	$30.00		
Sugar, thin glass, 2 1/2"	6.00	4.50	4.50		
Sugar, 3"	6.00	4.50	4.50		
Creamer, thin glass, 2 1/2"	6.00	4.50	4.50		
Creamer, 3"	6.00	4.50	4.50		

DORIC

Individual pieces	Green	Pink	Crystal	Delfite
Plate, 9"	$4.00	$3.00	$3.00	
Plate, grill, 9"	3.50	2.50	2.50	
Plate, 7"	2.50	2.00	2.00	
Plate, 6"	2.50	2.00	2.00	
Bowl, 5"	3.50	2.50	2.50	
Bowl, 4 1/2"	3.00	2.00	2.00	$13.50
Cup	4.00	3.00	3.00	
Saucer	3.00	2.50	2.50	
Tumbler, footed, 13 oz.	10.00	7.50	7.50	
Tumbler, footed, 10 oz.	8.50	6.50	6.50	
Tumbler, 9 oz.	7.50	5.50	5.50	
Sherbet	4.00	3.00	3.00	6.00
Coaster	4.00	3.00	3.00	

Serving pieces

	Green	Pink	Crystal	
Platter, 12"	10.50	6.50	6.50	
Plate, 19"	10.00	8.00	8.00	
Tray, with handles, 10"	8.00	6.00	6.00	
Bowl, oval, 9"	10.00	7.50	7.50	
Bowl, with handles, 9"	10.00	7.50	7.50	
Bowl, 8 3/4"	6.50	4.50	4.50	

Serving pieces (Cont.)	Green	Pink	Crystal	Delfite
Relish dish, 4" x 4"	$3.50	$2.50	$2.50	
Relish dish, 4" x 8"	3.00	2.00	2.00	
Relish dish, 8" x 8"	6.50	5.00	5.00	
Pitcher, 48 oz.	45.00	37.50	37.50	
Pitcher, 36 oz.	17.50	14.50	14.50	$37.50
Sugar and cover	6.50	4.50	4.50	
Creamer	6.00	4.00	4.00	
Butter dish and cover	37.50	28.50	28.50	
Candy jar and cover	15.00	12.50	12.50	
Salt and pepper	15.00	12.50	12.50	

Adjunctive piece

	Green	Pink	Crystal
Ash tray	4.00	3.00	3.00

DORIC AND PANSY

Individual pieces	Pink	Crystal	Ultra-marine
Plate, 9"	$3.00	$3.00	$8.00
Plate, 7"			6.00
Plate, 6"	2.50	2.50	6.00
Bowl, 4 1/2"	5.00	3.50	5.00
Cup	6.50	3.00	6.50
Saucer	4.00	2.00	5.00
Tumbler (2 shapes), 9 oz.		3.50	15.00

Serving pieces

	Pink	Crystal	Ultra-marine
Bowl, with handles, 9"			17.50
Bowl, 8 1/2"	10.00	10.00	15.50
Tray, with handles, 10"		6.50	10.50
Sugar	17.50	17.50	75.00

Serving pieces (Cont.)	Pink	Crystal	Ultra-marine
Creamer	$17.50	$17.50	$50.00
Butter dish and cover			350.00
Salt and pepper			50.00

Jeannette Junior Dinner Set (Pretty Polly Party Dishes)	Ultra-marine	Pink
Plate, 6"	$5.00	$5.00
Cup	22.50	17.50
Saucer	7.50	5.00
Sugar	25.00	22.50
Creamer	25.00	22.50
14-piece set	150.00	120.00
Set in original box	160.00	130.00

FIESTA

Individual pieces	Vitrock (white opal glass, applied colored bands)
Plate, 19"	$4.00
Plate, 9"	3.50
Plate, 8 3/4"	3.00
Plate, 7 1/4"	2.75
Bowl, 7 1/2"	3.00
Bowl, 6"	2.75
Shallow soup dish	3.00
Bowl, 4"	2.00
Cup	2.50
Saucer	1.75

Serving pieces

Platter, oval, 11 1/2"	5.50
Bowl, oval, 9 1/2"	5.00
Sugar	4.50
Creamer	4.50
Salt and pepper	10.00

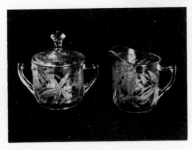
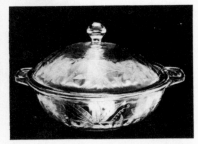

FLORAL

Individual pieces	Emerald Green	Rose Pink	Jadite
Plate, 9"	$3.50	$2.75	
Plate, 8"	3.00	2.50	
Plate, 6"	2.00	1.50	
Bowl, 7 1/2"	6.50	5.50	
Bowl, 4"	3.00	2.00	
Tumbler, footed, conical, 9 oz.	8.00	6.50	
Tumbler, footed, conical, 7 oz.	6.00	5.50	
Tumbler, footed, conical, 5 oz.	5.00	4.50	
Cup	3.50	2.50	
Saucer	3.00	2.00	
Sherbet	3.50	2.50	

Serving pieces			
Platter, 10 3/4"	6.00	5.00	
Tray (with handles), 6" sq.	8.50	6.50	

Serving pieces (Cont.)	Emerald Green	Rose Pink	Jadite
Relish dish, oval, 6 1/4" x 12"	$6.00	$5.50	
Bowl, oval, with cover, 9"	10.00	8.00	
Bowl, round, with cover, 8" dia.	7.50	5.00	
Sugar with cover	6.00	4.50	
Creamer	5.50	3.75	
Pitcher, footed, conical, 48 oz.	70.00	60.00	
Pitcher, footed, conical, 32 oz.	12.50	10.50	
Candy jar with cover	12.50	9.50	
Butter dish and cover	40.00	32.50	
Salt and pepper	15.00	10.00	
Coaster	3.50	2.50	

Adjunctive pieces

	Emerald Green	Rose Pink	Jadite
Rose bowl, 3-legged	15.00	12.50	
Ash tray	7.50	5.00	
Cannister set, square, 4 pieces, 5 3/4" high			$20.00
Refrigerator dish, with handles, 6 1/2" long	15.00		12.50
Refrigerator dish, with cover, 4 3/4" square	15.00		

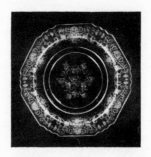

FLORENTINE (OLD, OR #1)

Individual pieces	Pink	Crystal, Green, Topaz	Ritz Blue
Plate, 9 3/4"	$3.50	$3.00	
Plate, grill, 9 3/4"	3.00	2.50	
Plate, 8"	2.50	2.00	
Plate, 6"	2.00	1.50	
Bowl, 6"	3.50	3.00	
Bowl, 4"	2.75	2.50	$9.00
Cup	3.50	2.50	
Saucer	2.25	1.75	
Tumbler, footed, 12 oz.	10.00	10.00	
Tumbler, footed, 9 oz.	7.00	7.00	
Tumbler, footed, 5 oz.	6.00	5.00	
Sherbet	4.00	3.00	
Coaster	5.00	4.00	

Serving pieces

	Pink	Crystal, Green, Topaz	Ritz Blue
Platter, oval, 11 1/2"	7.00	6.00	
Bowl, oval, 9 1/4"	10.00	7.00	
Bowl, 8 1/2"	10.50	9.00	20.00
Pitcher, ice lip, 54 oz.	20.00	17.50	
Pitcher, 54 oz.	17.50	15.00	
Pitcher, footed, 36 oz.	35.00	17.50	
Sugar with cover	7.50	6.00	
Creamer	5.50	3.50	
Sugar, no lid, ruffled edge	6.00	5.00	17.50
Creamer, ruffled edge	7.50	6.00	17.50

Serving pieces (Cont.)	Pink	Crystal, Green, Topaz	Ritz Blue
Butter dish with cover	$45.00	$37.50	
Salt and pepper	17.50	15.00	

Adjunctive piece

	Pink	Crystal, Green, Topaz	Ritz Blue
Ash tray		5.00	4.00

FLORENTINE (#2)

Individual pieces	Topaz	Pink, Green, Crystal	Ritz Blue
Plate, 10"	$3.50	$3.00	
Plate, grill, 10 1/2"	3.00	2.50	
Plate, 8 1/2"	2.50	2.00	
Plate, 6"	2.00	1.50	
Bowl, 6"	4.00	3.00	
Bowl, handled, 4 3/4"	4.00	3.50	
Bowl, 4 1/2"	3.00	2.50	
Cup	3.50	3.00	

Individual pieces (Cont.)	Topaz	Pink, Green, Crystal	Ritz Blue
Custard cup		$4.50	
Saucer	$2.50	1.50	
Tumbler, footed, 12 oz.	10.00	7.50	
Tumbler, footed, 9 oz.	6.00	5.50	
Tumbler, footed, 5 oz.	6.00	5.50	
Tumbler, 12 oz.	8.00	6.00	$15.00
Tumbler, 9 oz.	6.50	4.50	12.50
Tumbler, 5 oz.	6.00	4.00	12.50
Coaster, 3 3/4"	4.50	3.50	
Coaster, 3 1/4"	3.50	2.50	

Serving pieces

	Topaz	Pink, Green, Crystal	Ritz Blue
Platter, with gravy boat, 11 1/2"	35.00		
Platter, 11"	7.50	7.50	
Bowl, oval, with cover, 9"	17.50	17.50	
Bowl, 8"	10.50	9.00	
Bowl, ruffled edge, 5 1/2"	4.50	3.50	15.00
Relish dish (2 styles), 10"	6.75	6.75	
Butter dish with cover	40.00	40.00	
Candy dish with cover	25.00	22.50	
Pitcher, 80 oz.		27.50	
Pitcher, 54 oz.	37.50	27.50	
Pitcher, footed, conical, 36 oz.	15.00	15.00	
Sugar and cover	7.50	5.50	
Creamer	4.00	3.00	
Comport, ruffled edge, 3 1/2"	7.50	5.50	17.50
Round tray with creamer, sugar, salt and pepper	42.50		
Salt and pepper	15.00	12.50	

Adjunctive pieces

	Topaz	Pink, Green, Crystal	Ritz Blue
Candlesticks (pair), 3"	15.00	12.50	
Ash tray, 5 1/2"	6.50	5.00	
Vase, 6"	12.50	8.50	

FORTUNE

Individual pieces	Crystal	Pink
Plate, 8"	$1.50	$2.00
Plate, 6"	1.00	1.75
Bowl, 5 1/4"	1.25	2.00
Bowl, handled, 4 1/2"	1.00	1.50
Bowl, 4"	1.00	1.50
Cup	1.50	2.00
Saucer	1.00	1.50
Tumbler, 9 oz.	1.50	2.00
Tumbler, 5 oz.	1.00	1.50

Serving pieces

	Crystal	Pink
Bowl, 7 3/4"	2.00	2.50
Candy dish with cover	4.50	5.50

FRUITS

Individual pieces	Crystal	Pink	Green
Plate, 8"	$1.75	$2.25	$2.25
Bowl, 5"	3.50	4.50	4.50
Cup	3.50	4.50	4.50
Saucer	2.00	3.00	3.00
Tumbler (pears, grapes, cherries), 4"	6.50	7.50	7.50
Tumbler (grapes), 4"	5.50	6.50	6.50
Tumbler (cherries), 4"	5.50	6.50	6.50
Tumbler (pears), 4"	5.50	6.50	6.50
Sherbet	4.00	4.50	4.50

Serving pieces	Crystal	Pink	Green
Bowl, 8 1/4"	$10.50	$12.50	$12.50
Pitcher, 7"	22.50	25.00	25.00
Butter dish with cover	55.00	60.00	60.00

GEORGIAN

Individual pieces	Green
Plate (allover pattern) 9 1/2"	$3.50
Plate (border and center motifs only) 9 1/2"	3.00
Plate, 8"	2.00
Plate, 6"	1.75
Bowl, 6 1/2"	6.00
Bowl, 5 3/4"	3.00
Bowl, cream soup	9.00
Bowl, 4 1/2"	2.50
Cup	3.00
Saucer	2.25
Tumbler, 12 oz.	8.50
Tumbler, 9 oz.	7.50
Sherbet	2.50

Serving pieces	
Platter, 11"	6.00
Bowl, oval, 9"	6.00
Bowl, 7 1/2"	7.00
Sugar and cover, 4"	4.50
Creamer, 4"	3.50
Sugar and cover, 3"	3.50
Creamer, 3"	3.00
Butter dish and cover	30.00
Hot plate (also in crystal) 5" dia.	12.50
Wooden Lazy Susan, 7 hot plates	72.50

HERITAGE

Individual pieces	Pink	Crystal
Plate, 9 1/4"	$2.50	$2.00
Plate, 8"	2.00	1.50
Plate, 6"	1.25	1.00
Bowl, 5"	1.50	1.25
Cup	3.00	2.00
Saucer	1.50	1.00

Serving pieces		
Plate, 12"	4.50	3.50
Bowl, 10 1/2"	6.50	5.50
Bowl, 8 1/2"	5.50	4.50
Sugar	5.00	4.00
Creamer	5.00	4.00

HOLIDAY

Individual pieces	Pink
Plate, 9"	$2.50
Plate, 6"	1.50
Bowl, 7 3/4"	5.00
Bowl, 5"	1.75
Cup	2.50
Saucer	1.50
Tumbler, 10 oz.	6.00
Tumbler, footed, 6"	12.50
Tumbler, footed, 4"	8.00
Sherbet	2.50

-30-

Serving pieces

	Pink
Plate, 13 3/4"	$15.00
Platter, 11 1/2"	5.00
Plate, footed, 10 1/2"	12.50
Plate, 10 1/2"	7.50
Bowl, oval, 9 1/2"	5.00
Bowl, 8 1/2"	5.00
Sugar and cover	5.00
Creamer	3.50
Pitcher, 52 oz.	12.50
Pitcher, 16 oz.	10.00
Butter dish and cover	17.50

Adjunctive pieces

	Pink
Console bowl, 10 1/2"	17.50
Candlesticks (pair), 3"	17.50

HOMESPUN

Individual pieces

	Pink
Plate, 9 1/4"	$2.50
Plate, 6"	2.00
Bowl, 5"	2.00
Bowl, 4 3/4"	2.00
Cup	3.00
Saucer	2.00
Tumbler, footed, 15 oz.	7.50
Tumbler, footed, 9 oz.	5.50
Tumbler, footed, 5 oz.	3.50
Tumbler, 13 oz.	4.00
Tumbler, 9 oz.	3.00
Sherbet	3.00
Coaster	3.00

Serving pieces	Pink
Platter, 13"	$6.50
Bowl, 8 1/4"	6.50
Sugar	3.50
Creamer	3.50
Pitcher, tilted jug, 96 oz.	12.50
Butter dish with cover	25.00

Adjunctive piece

Ash tray	3.00

Homespun Tea Set
(child's dishes)

	Pink	Crystal
Plate, 4 1/2"	7.50	$5.50
Cup	10.00	8.00
Saucer	4.50	3.50
Teapot and cover	20.00	17.50
Complete set, 14 pieces	100.00	90.00

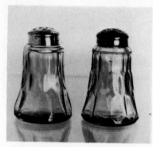

HONEYCOMB
(JEANNETTE'S HEXAGONAL OPTIC)

Individual pieces	Pink	Green
Plate, 8"	$2.50	$3.00
Plate, 6"	1.50	2.00
Bowl, ruffled edge, 4 1/2"	2.00	2.50
Cup	2.50	3.00
Saucer	2.50	3.00
Tumbler, footed, 7"	6.00	7.00
Tumbler, footed, 5 3/4"	5.00	5.50
Tumbler, 7"	3.00	3.50
Tumbler, 5"	3.00	3.50

Individual pieces (Cont.)	Pink	Green
Tumbler, 4"	$2.00	$2.50
Tumbler, 2"	2.00	2.50
Sherbet	2.00	2.50

Serving pieces

	Pink	Green
Platter, 11"	6.50	7.50
Bowl, 7 1/4"	5.00	6.00
Sugar bowl, tab handle	3.00	3.50
Creamer, tab handle	3.00	3.50
Sugar bowl, loop handle	3.00	3.50
Creamer, loop handle	3.00	3.50
Pitcher, conical, 9"	17.50	20.00
Pitcher, 5"	8.00	10.00
Ice bucket, bail handle	10.00	12.50
Ice bucket	8.00	10.00
Salt and pepper	7.50	10.00

Adjunctive piece

	Pink	Green
Refrigerator dishes	5.00	7.50

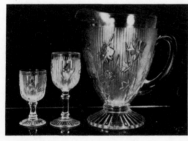 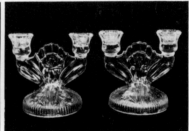

IRIS

Individual pieces	Green	Pink	Crystal	Iridescent Amber
Plate, 9"	$10.00	$10.00	$3.00	$5.00
Plate, 8"			2.50	4.50
Plate, 5 1/2"			2.00	3.00
Bowl, 6"			2.50	3.50
Bowl, 5"			2.50	3.50
Bowl, 4 1/2"			2.00	3.00
Cup			3.00	4.00

Individual pieces (Cont.)	Green	Pink	Crystal	Iridescent Amber
Saucer			$2.00	$3.00
Tumbler, footed, 7"			5.00	5.50
Tumbler, footed, 6"			4.50	5.00
Tumbler, 4"			6.00	12.50
Goblet, 7"			5.00	10.50
Goblet, 5 3/4"			6.00	10.50
Goblet, 4 1/2"			6.00	10.50
Sherbet, 4"			3.00	5.00
Sherbet, 3 1/2"			3.00	5.00
Coaster			2.00	3.00
Demitasse cup and saucer			5.50	

Serving pieces

	Green	Pink	Crystal	Iridescent Amber
Plate, 11 3/4" (also with metal or plastic cover)	$12.50	$12.50	6.50	6.50
Bowl, fluted edge, 11"			6.00	7.50
Bowl, 11"			6.00	7.50
Bowl, 9"			5.00	6.50
Bowl, 8"			5.00	5.50
Pitcher, 9 1/2"			10.00	15.00
Butter dish and cover			12.50	17.50
Candy jar and cover			22.50	27.50
Sugar with cover	12.50	12.50	4.00	5.00
Creamer	10.00	10.00	4.00	5.00

Adjunctive pieces

	Green	Pink	Crystal	Iridescent Amber
Candlesticks (pair)			12.50	17.50
Vase	25.00	25.00	12.50	17.50

LACE EDGE

Individual pieces	Pink
Plate, 10 1/2"	$3.75
Plate, grill, 10 1/2"	3.50
Plate, 8 1/2"	3.00
Plate, 7 1/4"	2.50
Bowl, 7 3/4"	4.00
Bowl, 6 1/2"	3.00
Cup	5.00
Saucer	2.50
Tumbler, footed, 10 1/2 oz.	8.50
Sherbet	7.50

Serving pieces	
Platter, 12 3/4"	6.00
Plate, relish, 3 sections, 10 1/2"	7.00
Plate, relish, 5 sections, 12 3/4"	9.00
Comport, 7"	4.50
Comport with cover	6.00
Preserve dish with cover	17.50

Serving pieces (Cont.)

	Pink
Cookie jar with cover	$12.50
Sugar	5.00
Creamer	4.00
Relish dish, 7 1/2"	7.50

Adjunctive pieces

	Pink
Flower bowl	5.00
Vase, 7"	12.50
Fish bowls,	
1/2 gal.	4.00
1 gal.	6.00
2 gal.	10.00
(only in crystal)	
Candlesticks (pair)	22.50

LORAIN

Individual pieces	Green	Topaz	Crystal
Plate, 10 1/4"	$4.00	$4.00	$3.50
Plate, 9 1/2"	3.00	3.00	2.50
Plate, 8 1/2"	2.50	2.50	2.00
Plate, 6"	2.00	2.00	1.50
Bowl, 6"	4.00	4.00	3.00
Cup	3.50	3.50	2.50
Saucer	3.00	3.00	2.00
Tumbler, 9 oz.	5.00	5.00	3.00
Sherbet	3.00	3.00	2.00

Serving pieces	Green	Topaz	Crystal
Platter, 11 1/2"	$8.00	$8.00	$6.00
Plate, 11 1/2"	7.50	7.50	5.50
Bowl, oblong, 9 3/4"	8.00	8.00	7.00
Bowl, 8"	7.50	7.50	6.00
Bowl, 7 1/2"	5.00	5.00	4.00
Relish dish, 4-part, 8"	5.00	5.00	4.00
Sugar	3.50	3.50	2.50
Creamer	3.50	3.50	2.50

 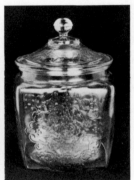

MADRID*

Individual pieces	Pink, Amber	Crystal	Green	Madonna Blue
Plate, 10 1/2"	$6.50	$5.50	$6.50	$8.50
Plate, grill, 10 1/2"	5.50	4.50	5.50	6.50
Plate, 9"	2.50	2.00	3.00	5.50
Plate, 7 1/2"	2.50	2.00	3.00	5.00
Plate, 6"	2.00	1.50	2.50	4.00
Bowl, 7"	3.50	2.50	4.00	8.50
Bowl, 5"	3.50	3.00	4.00	5.00
Bowl, handled, 5"	4.00	3.00	4.50	
Cup	3.50	2.50	4.00	8.50
Saucer	2.50	2.00	3.00	4.00
Tumbler, footed, 10 oz.	7.00	6.00	7.50	

*See color plates 6 and 8 in The Collector's Guide to Depression Glass.

Individual pieces (Cont.)	Pink, Amber	Crystal	Green	Madonna Blue
Tumbler, footed, 5 oz.	$8.50	$7.50	$9.00	
Tumbler (2 styles) 12 oz.	5.00	4.50	6.00	$12.50
Tumbler, 9 oz.	5.00	4.50	6.00	10.00
Tumbler, 5 oz.	6.00	5.00	6.50	8.00
Sherbet (2 styles)	2.50	2.00	3.00	6.00

Serving pieces

	Pink, Amber	Crystal	Green	Madonna Blue
Platter, 11 1/2"	6.00	5.00	7.00	12.50
Plate, 11 1/2"	5.00	4.00	6.50	
Plate, relish, 10 1/2"	5.00	4.00	6.00	
Bowl, oval, 10"	5.00	4.00	6.00	10.00
Bowl, 9 1/2"	8.00	7.00		
Bowl, 9"	7.50	6.00	9.00	12.50
Bowl, 8 1/4"	6.50	5.50	8.00	10.50
Sugar and cover	6.50	5.00	12.50	17.50
Creamer	3.00	2.50	10.50	12.50
Pitcher, ice lip, 80 oz.	25.00	18.50	30.00	47.50
Pitcher, 80 oz.	22.50	17.50	25.00	45.00
Pitcher, square, 60 oz.	15.50	12.50	20.00	80.00
Pitcher, 36 oz.	13.00	10.00		
Preserve dish, 7"	5.00	4.00	6.00	7.50
Butter dish and cover	30.00	25.00	35.00	125.00
Cracker jar and cover	17.50	15.00	20.00	40.00
Gravy boat and underdish (amber only)	145.00			
Salt and pepper	14.00	12.50	16.00	47.50

Adjunctive pieces	Pink, Amber	Crystal	Green	Madonna Blue
Console bowl, flared edge, 11" (also in iridescent orange)	$7.50	$6.50	$17.50	
Candlesticks (pair), 2" (also in iridescent orange)	12.50	7.50	15.00	$17.50
Jell-O mold, 2" high	3.50	2.50	6.50	
Hot plate, 5"	13.50	11.00	15.00	27.50
Hot plate with indented ring, 5"	13.50	11.00	15.00	27.50

MANHATTAN

Individual pieces	Pink	Crystal
Plate, 10 1/4"	$2.50	$2.00
Plate, 8"	2.00	1.50
Plate, 6"	1.50	1.00
Bowl, handled, 5 1/2"	1.25	1.00
Bowl, 4 1/2"	1.25	1.00
Cup	2.00	1.50
Saucer	1.50	1.00
Tumbler, footed, 10 oz.	3.50	3.00
Sherbet	2.00	1.50
Coaster	2.00	1.50

Serving pieces		
Plate, 14"	5.00	3.00
Plate, relish, 4-part, 14"	6.00	4.00
Bowl, handled, 9 1/2"	5.50	3.50
Bowl, 9"	5.50	3.00
Bowl, 7 1/2"	4.50	2.50
Comport, 5 3/4"	3.50	2.50
Pitcher, ice lip, 80 oz.	8.00	5.00
Pitcher, 42 oz.	6.00	4.00
Sugar	3.00	2.00
Creamer	3.00	2.00
Salt and pepper	10.00	5.00
Lazy Susan, 5 sections, 14"	10.00	6.00

Adjunctive pieces	Pink	Crystal
Candlesticks (pair), 4 1/4"	$8.00	$4.00
Ash tray, 4"	2.00	1.00
Vase, 8"	7.50	3.50

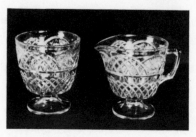

MAYFAIR (FEDERAL)

Individual pieces	Amber	Crystal
Plate, 9 1/2"	$3.50	$2.50
Plate, grill, 9 1/2"	3.00	2.00
Plate, 6 3/4"	2.50	1.50
Bowl, 6"	2.25	1.75
Bowl, 5"	2.00	1.50
Cup	3.50	2.50
Saucer	2.00	1.00
Tumbler, 9 oz.	5.50	4.50

Serving pieces		
Platter, 12"	8.00	6.50
Bowl, oval, 10"	7.50	6.00
Sugar	4.00	3.00
Creamer	4.00	3.00

MAYFAIR (HOCKING)*

Individual pieces	Pink	Blue	Green	Topaz
Plate, 9 1/2"	$5.00	$12.50		
Plate, grill, 9 1/2"	4.00	10.00		
Plate, 8 1/2"	3.00	8.50		
Plate, 6 1/2"	2.50	7.00		
Plate (off-center ring indented), 6 1/2"	6.00	10.50		
Plate, 6"	3.00	6.00		
Bowl, 5 1/2"	3.50	8.50		
Bowl, 5"	7.50			
Cup	4.50	17.50		
Saucer	3.00	6.50		
Tumbler, footed, 15 oz.	7.00	25.00	$67.50	
Tumbler, footed, 10 oz.	5.00	22.50		
Tumbler, footed, 3 oz.	17.50			
Tumbler, 13 1/2 oz.	9.00	22.50		

*See color plates 3, 9, 13, and 14 in The Collector's Guide to Depression Glass.

-41-

Individual pieces (Cont.)	Pink	Blue	Green	Topaz
Tumbler, 10 oz.	$6.00	$17.50		
Tumbler, 9 oz.	5.00	17.50		
Tumbler, 5 oz.	6.50	17.50		
Tumbler (whiskey), 1 1/2 oz.	35.00			
Goblet (blown glass) 9 oz.	27.50	37.50		
Goblet, 9 oz.	12.50			
Goblet, 3 1/2 oz.	27.50			
Goblet, 3 oz.	27.50			
Sherbet (blown glass) 4 3/4"	13.50	17.50		
Sherbet, 3 1/4"	4.00			$27.50
Sherbet, 2 1/4"	10.00	14.50		

Serving pieces

	Pink	Blue	Green	Topaz
Platter, 12"	5.00	15.00	$27.50	50.00
Plate, 12"	6.00	27.50	12.50	47.50
Plate (divided), 12" (crystal, $5.00)				
Plate, footed, 10"	7.50	22.50		
Bowl, flared edge, 12"	10.00	27.50	12.50	42.50
Bowl, 11 3/4"	10.00	27.50	12.50	
Bowl with cover, 10"	17.50	32.50		
Bowl, handled, 19"	5.00	17.50		
Bowl, 7"	5.50	12.50		
Sugar	5.00	17.50	30.00	
Sugar with cover (no price, very rare)				
Creamer	5.00	17.50	30.00	
Relish dish, 4 sections, 8 1/4"	6.00	17.50	47.50	35.00
Cookie jar and cover	10.00	32.50	75.00	
Butter dish and cover	22.50	127.50		
Candy jar and cover	15.00	47.50	80.00	80.00
Relish dish, 2-part, 10 1/2"		14.50		
Celery dish, 10"	5.50		27.50	42.50
Sandwich tray, center post	7.50	22.50	10.00	
Decanter and stopper	42.50			
Salt and pepper	15.00	55.00		

Adjunctive pieces

	Pink	Blue	Green	Topaz
Console bowl, 3-legged, 9"	225.00			
Sweet pea vase, 8 1/2"	22.50	27.50	50.00	

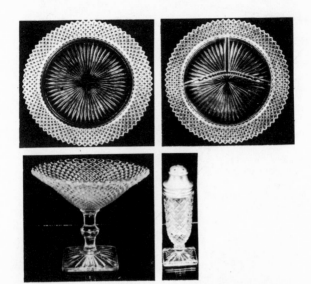

MISS AMERICA*

Individual pieces	Pink	Green	Crystal
Plate, 10 1/4"	$5.50	$6.50	$4.50
Plate, grill, 10 1/4"	5.00	6.00	4.00
Plate, 8 1/2"	4.00	5.00	3.00
Plate, 6 3/4"	3.00	4.00	2.00
Plate, 5 3/4"	3.00	2.00	1.75
Bowl, 6 1/4"	5.00	4.00	3.00
Bowl, 4 1/2"	3.50	3.50	2.50
Cup	6.00	6.00	5.00
Saucer	4.00	4.00	3.50
Tumbler, 14 oz.	12.00		8.00
Tumbler, 10 oz.	8.50		5.50
Tumbler, 5 oz.	10.50		5.00
Goblet, 10 oz.	17.50		10.00
Goblet, 5 1/2 oz.	15.00		7.50
Goblet, 3 oz.	22.50		10.00
Sherbet	5.00		3.50
Coaster	9.00		5.00

*See color photos on front cover of jacket for The Collector's
Guide to Depression Glass.

Serving pieces	Pink	Green	Crystal
Platter, 12"	$7.50		$7.50
Plate, footed, 12"	12.50		12.50
Relish dish, divided, 12"			10.00
Relish dish, 4 sections, 8 1/2"	6.00		6.00
Bowl, oval, 10"	7.00		7.00
Bowl, 8"	22.50		17.50
Bowl (curved inward at top) 8"	22.50		17.50
Butter dish and cover	175.00		125.00
Candy jar and cover	47.50		37.50
Comport, 5"	7.50		5.50
Celery tray, oblong, 10 1/2"	7.50		5.50
Tidbit server, 2-tier (10 1/4", 8 1/2" plates)	17.50		12.50
Candy dish, metal cover, 6 1/4"			8.50
Salt and pepper	17.50		12.50

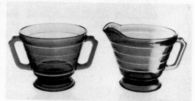

MODERNTONE*

Individual pieces	Ritz Blue, Burgundy
Plate, 9"	$3.00
Plate, 8"	2.50
Plate, 7"	2.00
Plate, 6"	1.50
Bowl, 7 3/4"	5.00
Bowl, 6 1/2"	4.50
Bowl, 5"	3.50
Bowl, handled, 4 3/4"	5.00
Cup	4.00
Saucer	3.00
Tumbler, 12 oz.	6.00

*See color plate 14 in The Collector's Guide to Depression Glass.

Individual pieces (Cont.) Ritz Blue, Burgundy

Tumbler, 9 oz. $5.00
Tumbler, 5 oz. 4.00
Sherbet 3.50
Jell-O or custard cup 3.50

Serving pieces

Platter, 12" 7.50
Platter, 11" 6.50
Plate, 10 3/4" 6.00
Bowl, 9" 7.50
Bowl, ruffled edge, 5" 4.00
Sugar 3.50
Creamer 3.00
Butter dish (metal cover) 27.50
Salt and pepper 12.50

Adjunctive piece

Ash tray, 5 1/2" 3.50

"Little Hostess Party Set,"
 child's toy dish set in
 cobalt blue or Platonite
 (opaque white) with fired-on
 colors

Plate 3.00
Cup 2.50
Saucer 2.00
Creamer 3.25
Sugar 3.25

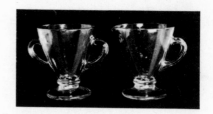

NEW CENTURY

Individual pieces	Green	Black
Plate, 8"	$2.00	$3.00
Bowl, 5 1/2"	1.50	3.00
Bowl, 4 3/4"	1.00	2.00
Cup	1.50	2.50
Saucer	1.00	2.00
Fruit dish, footed	1.00	2.00
Sherbet	1.50	2.50

Serving pieces		
Sugar	2.00	3.00
Creamer	2.00	3.00
Salt and pepper	5.00	10.00

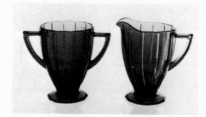

NEWPORT

Individual pieces	Ritz Blue, Burgundy	Pink Platonite
Plate, 8 1/2"	$4.00	$2.50
Plate, 6"	3.00	2.00
Bowl, 5 1/2"	3.50	2.25
Bowl, 4 3/4"	3.50	2.50
Bowl, 4 1/4"	3.00	2.00
Cup	2.50	2.00
Saucer	2.00	1.75

Individual pieces (Cont.)	Ritz Blue, Burgundy	Pink Platonite
Tumbler, 4 1/2"	$4.50	$3.00
Sherbet	4.50	3.00

Serving pieces

	Ritz Blue, Burgundy	Pink Platonite
Plate, 11 1/2"	10.00	4.00
Bowl, 8 1/4"	7.50	3.00
Sugar	6.00	4.00
Creamer	5.00	4.00
Salt and pepper	17.50	12.50

NORMANDIE*

Individual pieces	Pink, Green, Amber, Crystal	Sunburst (Iridescent Carnival)
Plate, 10 1/2"	$3.50	$4.50
Plate, grill, 10 1/2"	3.00	3.50
Plate, 9 1/4"	2.50	3.00
Plate, 8"	2.50	3.00
Plate, 6"	1.50	2.50
Bowl, 5"	1.75	1.75
Cup	3.00	4.00
Saucer	2.00	2.50
Tumbler, 12 oz.	5.50	
Tumbler, 9 oz.	4.50	
Tumbler, 5 oz.	4.50	
Sherbet	2.00	

*See color plates 2 and 18 in The Collector's Guide to Depression Glass.

Serving pieces	Pink, Green, Amber, Crystal	Sunburst (Iridescent Carnival)
Platter, 12"	$7.50	$7.50
Bowl, oval, 9 1/2"	7.50	8.50
Bowl, 8 1/2"	6.50	9.00
Bowl (preserve dish), 6 1/2"	3.50	4.50
Sugar and cover	6.00	5.00 (no cover)
Creamer	4.00	5.00
Pitcher, 80 oz.	27.50	
Salt and pepper	15.00	

NUMBER 612 (HORSESHOE)

Individual pieces	Yellow, Pink	Green, Crystal
Plate, 10 1/2"	$4.50	$3.50
Plate, grill, 10 1/2"	4.50	3.50
Plate, 9 1/2"	4.25	3.00
Plate, 8 1/2"	3.50	2.50
Plate, 6"	2.50	2.00
Bowl, 6 1/2"	4.25	3.25
Bowl, 4 1/2"	3.75	2.50
Cup	3.50	2.50
Saucer	2.50	2.00
Tumbler, footed, 12 oz.	8.00	7.00
Tumbler, footed, 9 oz.	7.00	6.00
Tumbler, 9 oz.	7.50	5.50
Sherbet	3.50	2.50

Serving pieces	Yellow, Pink	Green, Crystal
Plate, 11 1/4"	$7.50	$5.50
Platter, 10 3/4"	9.00	7.00
Bowl, oval, 10"	10.50	7.50
Bowl, 9"	14.50	10.00
Bowl, 7 1/2"	10.00	8.50
Pitcher, 64 oz.	70.00	50.00
Relish dish, 3 sections	7.50	5.50
Butter dish and cover	125.00	75.00
Candy dish and cover (metal holder)	30.00	20.00
Sugar	6.50	5.50
Creamer	6.50	5.50

OLD CAFE

Individual pieces	Pink	Crystal	Royal Ruby
Plate, 10"	$3.25	$2.50	
Plate, 6 1/2"	1.50	1.00	
Bowl, 5 1/2"	1.25	1.00	$3.50
Bowl, 5"	1.25	1.00	
Bowl, 3 3/4"	1.25	1.00	3.00
Cup	2.50	2.00	3.50
Saucer	1.50	1.00	
Tumbler, 4"	2.50	1.50	
Tumbler, 3"	2.00	1.00	
Sherbet	2.00	1.00	

Serving pieces	Pink	Crystal	Royal Ruby
Bowl, 9"	$3.50	$3.00	
Relish dish, oblong, 6"	3.00	2.00	
Candy tray, flared, 8"	2.50	2.00	$6.00
Salt and pepper	10.00	6.00	

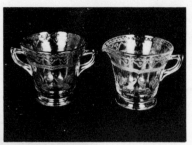
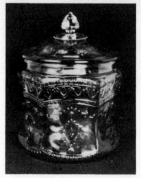

PATRICIAN*

Individual pieces	Pink	Green	Crystal	Amber
Plate, 10 1/2"	$4.00	$3.50	$2.00	$3.00
Plate, grill, 10 1/2"	3.50	3.00	2.00	3.00
Plate, 9"	3.00	2.75	1.50	2.00
Plate, 7 1/2"	3.00	2.75	1.50	2.00
Plate, 6"	2.50	2.00	1.00	1.50

*See color plates 8 and 11 in The Collector's Guide to Depression Glass.

Individual pieces (Cont.)	Pink	Green	Crystal	Amber
Bowl, 6"	$3.50	$3.50	$2.00	$3.00
Bowl, 5"	3.25	3.25	2.00	3.00
Bowl, 4 3/4"			2.50	3.00
Cup	3.50	3.50	2.50	3.00
Saucer	2.50	2.50	2.00	2.25
Tumbler, footed, 10 oz.	10.00	12.50	7.50	8.50
Tumbler, 12 oz.	8.50	8.50	6.50	7.50
Tumbler, 9 oz.	7.50	7.50	5.50	6.50
Tumbler, 5 oz.	8.00	8.50	5.00	7.50
Sherbet	3.50	3.00	1.50	2.50

Serving pieces				
Platter, 11 1/2"	8.00	7.00	5.00	6.00
Bowl, oval, 10"	7.50	6.50	4.50	5.50
Bowl, 8 1/2"	8.50	7.50	5.50	6.50
Sugar and cover	12.50	10.00	7.50	8.50
Creamer	4.00	4.00	3.00	3.50
Pitcher, 80 oz.	47.50	30.00	17.50	25.00
Pitcher, 68 oz.	37.50	30.00	22.50	27.50
Pitcher, 60 oz.	32.50	27.50	20.00	25.00
Cookie jar and cover	32.50	28.00	13.00	15.00
Butter dish and cover	47.50	45.00	35.00	37.50
Preserve dish, 6"			4.00	5.00
Salt and pepper	20.00	17.50	13.00	15.00

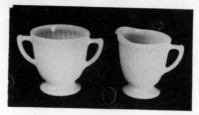

PETALWARE*

Individual pieces	Pink	Crystal	Monax, Cremax, Ivrene	Ritz Blue
Plate, 9 1/4"	$2.50	$2.00	$3.50	
Plate, 8"	2.00	1.50	3.00	
Plate, 6"	1.50	1.00	2.50	
Bowl, 5 3/4"	2.00	1.50	2.00	
Bowl, 4"	3.50	2.50	4.00	
Cup	2.50	2.00	5.50	
Saucer	2.00	1.50	3.00	
Sherbet	2.50	1.50	3.00	

Serving pieces				
Platter, 13"	4.00	3.00	7.50	
Plate, 12"			6.50	
Plate, 11"	4.00	3.00	5.50	
Bowl, oval, 9 1/4"	5.50	3.50	8.50	
Bowl, 8"	6.00	4.00	8.00	$27.50
Sugar	3.00	2.00	5.00	
Creamer	3.00	2.00	5.00	
Mayonnaise jar, metal lid (ritz blue only)				6.50

*See color plates 17 and 21 in The Collector's Guide to Depression Glass.

Serving pieces (Cont.)	Pink	Crystal	Monax, Cremax, Ivrene	Ritz Blue
Tidbit server, wood post, metal ring			$10.00	
Tidbit server, inverted saucer, 11" plate on bottom, sherbet on top, plastic center post			12.50	
Tidbit server, 11" plate on bottom, 9" bowl on top			17.50	

Adjunctive pieces

Lamp shades, several sizes			10.00	

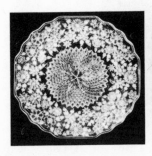 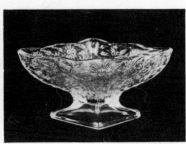

PINEAPPLE AND FLORAL

Individual pieces	Amber	Crystal
Plate, grill, 10 1/2"	$3.50	$2.50
Plate, 9 1/2"	4.00	3.00
Plate, 8 1/2"	3.00	2.50
Plate, 6"	2.50	2.00
Bowl, 6"	3.00	2.00
Bowl, handled, 5"	5.50	4.50
Cup	4.00	4.00
Saucer	2.50	2.00
Tumbler, 12 oz.	7.50	6.00
Tumbler, 9 oz.	6.00	5.00
Sherbet	4.00	3.00

Serving pieces	Amber	Crystal
Platter, 11 1/2"	$5.00	$4.00
Plate, 11 1/2"	6.50	4.50
Platter, relish, 11 1/2"	5.00	4.00
Bowl, oval, 10"	6.50	5.00
Bowl, 7 1/2"	6.00	4.50
Sugar	4.50	3.50
Creamer	4.50	3.00
Comport, diamond-shaped, 6 1/4"	2.50	2.00
Tidbit set, center post, 2-tier (11" plate, 8" plate)	12.50	10.00
Tidbit set, center post, (9" plate, 6" plate)	8.50	7.00

PRINCESS

Individual pieces	Pink	Green	Topaz
Plate, 9 1/2"	$3.00	$3.50	$3.50
Plate, grill, 9 1/2"	2.75	3.00	3.00
Plate, 8"	2.50	3.00	2.50
Plate, 6"	2.00	2.50	2.00
Bowl, 5 1/2"	4.00	3.50	4.00
Bowl, 4 1/2"	3.50	2.50	4.00
Cup	3.25	3.00	3.25
Saucer	2.00	2.00	2.00
Tumbler, footed, 12 1/2 oz.	10.50	8.50	
Tumbler, footed, 10 oz.	8.00	7.00	8.00
Tumbler, 12 1/2 oz.	8.00	6.00	10.00
Tumbler, 9 oz.	6.00	4.00	
Tumbler, 5 oz.	6.50	5.50	6.50
Sherbet	3.00	2.50	3.50
Coaster, 4"	5.00	4.00	5.00

Serving pieces	Pink	Green	Topaz
Platter, 12"	$5.50	$4.50	$7.50
Plate, handled, 11 1/2"	5.50	4.50	
Plate, handled, divided, 11 1/2"	6.50	5.50	8.50
Plate, footed, 10"	5.50	4.50	
Bowl, oval, 10"	5.50	4.50	9.00
Bowl, octagonal, 9"	7.00	5.00	12.50
Sugar and cover	5.50	4.50	6.50
Creamer	4.00	3.00	4.00
Pitcher, 60 oz.	22.50	17.50	27.50
Pitcher, 36 oz.	12.50	10.50	17.50
Relish dish, divided, 7 1/2"	5.00	4.00	6.50
Butter dish and cover	35.00	30.00	
Cookie jar and cover	10.50	7.50	
Candy jar and cover	10.00	8.00	
Salt and pepper (pink only) 5 1/2"	14.00		
Salt and pepper, 4 1/2"	12.50	9.00	17.50

Adjunctive pieces	Pink	Green	Topaz
Flared bowl, 9 1/2"	7.50	6.50	12.50
Vase, 8"	9.00	7.50	
Ash tray, 4"	6.50	5.50	

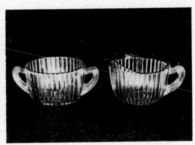

QUEEN MARY

Individual pieces	Pink	Crystal
Plate, 10"	$3.50	$2.00
Plate, 8 1/2"	2.50	1.50
Plate, 6 3/4"	2.00	1.50
Plate, 6"	2.00	1.50
Bowl, 6"	1.50	1.00

Individual pieces (Cont.)	Pink	Crystal
Bowl, handled, 5 1/2"	$1.50	$1.00
Bowl, 5"	1.50	1.00
Bowl, 4"	1.50	1.00
Bowl, one handle, 4"	1.50	1.00
Cup	2.25	1.75
Saucer	1.50	1.00
Tumbler, footed, 10 oz.	5.00	4.00
Tumbler, 9 oz.	3.00	3.00
Tumbler, 6 oz.	2.50	2.00
Sherbet	1.50	1.50
Coaster, 3 1/2"	1.00	1.00

Serving pieces

	Pink	Crystal
Plate, 14"	5.00	4.00
Plate, 12"	3.50	3.00
Bowl, 9"	3.50	3.00
Bowl, 7 1/2"	2.50	2.00
Relish dish, 4-part, 13"	3.50	2.50
Relish dish, 3-part, 12"	5.00	4.00
Preserve dish and cover	8.50	7.50
Comport, 5 3/4" dia.	4.50	3.50
Celery dish	3.50	2.25
Candy jar and cover	10.00	7.50
Salt and pepper	9.00	7.00

Adjunctive pieces

	Pink	Crystal
Candlesticks (pair), 4 1/2"	4.50	4.50
Coaster ash tray, 4 1/4"	1.50	1.50
Ash tray, oval, 3 3/4" long	1.50	1.50

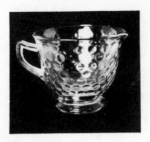

RAINDROPS

Individual pieces	Green
Plate, 8"	$2.00
Plate, 6 1/4"	1.50
Cup	2.00
Saucer	1.50
Tumbler, 3"	2.00
Tumbler, 2"	1.50
Sherbet	1.50

Serving pieces	
Bowl, 6"	1.50
Sugar and cover	3.50
Creamer	2.00

RIBBON

Individual pieces

	Green
Plate, 8"	$2.50
Plate, 6 1/4"	1.50
Bowl, 4"	1.50
Cup	2.50
Saucer	1.50
Tumbler, footed, 13 oz.	6.00
Tumbler, footed, 10 oz.	4.00
Tumbler, 4"	4.00
Sherbet	2.00

Serving pieces

Bowl, 8"	4.50
Sugar	2.50
Creamer	2.50
Candy dish and cover	5.00
Salt and pepper	7.50

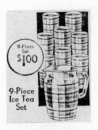

9-Piece
Ice Tea
Set

RING

Individual pieces	Green	Crystal	Crystal with Applied Decoration
Plate, 8"	$1.50	$1.00	$1.50
Plate, off-center ring, 6 1/2"	1.25	1.00	1.50
Plate, 6"	1.50	1.25	1.50
Bowl, 5"	1.00	1.00	1.25
Cup	1.75	1.50	1.75
Saucer	1.00	1.00	1.00
Tumbler, footed, 6"	4.00	3.50	4.00
Tumbler, footed, 5"	3.50	3.00	3.50
Tumbler, footed, 3"	3.00	2.50	3.00
Tumbler, 12 oz.	3.00	2.50	3.00
Tumbler, 9 oz.	2.50	2.00	2.50
Tumbler, 5 oz.	2.50	2.00	2.50
Goblet, 7"	6.00	4.00	6.00
Sherbet	2.50	2.00	2.50

Serving pieces

	Green	Crystal	Crystal with Applied Decoration
Sandwich server	5.00	4.00	5.00
Bowl, 8"	4.00	3.00	4.00
Pitcher, 80 oz.	10.50	7.50	12.50
Pitcher, 60 oz.	8.50	6.50	10.50
Salt and pepper	6.00	5.00	7.50
Sugar	2.50	2.00	3.00
Creamer	2.50	2.00	3.00
Decanter and stopper	10.00	8.00	9.00
Cocktail shaker	7.50	5.50	8.50
Ice bucket	4.50	4.00	5.50

Adjunctive pieces

	Green	Crystal	Crystal with Applied Decoration
Vase, 8"	3.50	3.00	4.00
Vase, 3"	3.00	2.50	3.50

ROSE CAMEO

Individual pieces	Green
Plate, 7"	$2.00
Bowl, 5"	2.00
Bowl, 4 1/2"	1.50
Cup	2.50
Saucer	2.00
Tumbler, footed, 6"	3.50
Tumbler, footed, 5"	3.50
Sherbet	2.00

ROSEMARY

Individual pieces	Green, Pink	Amber, Crystal
Plate, 9 1/2"	$2.50	$2.00
Plate, grill, 9 1/2"	2.50	2.00
Plate, 6 3/4"	2.00	1.50
Bowl, 6"	2.50	2.00
Bowl, 5"	2.50	2.00
Bowl, 5"	2.50	2.00

Individual pieces (Cont.)	Green, Pink	Amber, Crystal
Cup	$4.00	$3.00
Saucer	2.50	2.00
Tumbler, 9 oz.	7.50	6.50

Serving pieces

Platter, oval, 12"		
Bowl, oval	7.50	6.50
Sugar	3.00	2.50
Creamer	4.00	3.00

ROULETTE

Individual pieces	Crystal	Pink	Green
Plate, 8 1/2"	$1.50	$2.00	$2.00
Plate, 6"	1.25	1.75	1.75
Cup	2.00	3.00	3.00
Saucer	1.50	2.00	2.00
Tumbler, footed, 10 oz.	4.50	5.00	5.00
Tumbler, 12 oz.	5.50	6.50	6.50
Tumbler, 9 oz.	3.50	4.50	4.50
Tumbler, 7 1/2 oz.	3.50	4.50	4.50
Tumbler, 5 oz.	2.50	3.50	3.50
Tumbler, whiskey, 1 1/2 oz.	4.00	4.50	4.50
Sherbet	2.00	2.50	2.50

Serving pieces

Plate, 12"	5.00	6.00	6.00
Bowl, 9"	5.00	6.00	6.00
Pitcher, 64 oz.	14.00	17.50	17.50

ROUND ROBIN

Individual pieces	Green
Plate, 8"	$2.00
Plate, 6"	1.50
Bowl, 4"	1.00
Cup	2.50
Saucer	1.50
Sherbet	1.50

Serving pieces	
Plate, 12"	4.50
Sugar	3.00
Creamer	2.50

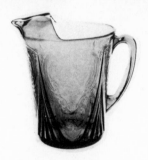

ROYAL LACE*

Individual pieces	Crystal, Pink	Green	Ritz Blue
Plate, 10"	$4.00	$6.50	$12.50
Plate, grill, 10"	3.50	5.50	10.00
Plate, 8 1/2"	3.00	5.00	8.50
Plate, 6"	2.50	4.50	5.50
Bowl, 5"	3.00	4.00	5.00
Bowl, cream soup, 5"	5.00	6.00	8.50
Cup	4.00	7.50	12.50
Saucer	3.00	4.00	4.50
Tumbler, 12 oz.	7.50	12.50	14.50
Tumbler, 10 oz.	5.50	10.50	12.50
Tumbler, 9 oz.	5.50	10.50	12.50
Tumbler, 5 oz.	6.00	7.00	10.00
Sherbet	3.00	5.00	10.00
Sherbet in metal holder (crystal only)	4.00		12.50

*See color plates 1 and 15 in The Collector's Guide to Depression Glass.

-63-

Serving pieces	Crystal, Pink	Green	Ritz Blue
Platter, 13"	$6.50	$12.50	$17.50
Bowl, oval, 10"	7.50	12.50	17.50
Bowl, rolled edge, 10"	17.50	27.50	35.00
Bowl, 3 legs (fruit), 10"	12.50	22.50	25.00
Pitcher, 96 oz.	22.50	47.50	75.00
Pitcher, 80 oz.	22.50	40.00	60.00
Pitcher, 68 oz.	20.00	37.50	45.00
Pitcher, 54 oz.	22.50	45.00	50.00
Sugar and cover	7.50	10.00	22.50
Creamer	4.00	6.00	15.00
Cookie jar and cover	15.00	30.00	50.00
Butter dish and cover	40.00	130.00	130.00
Salt and pepper	17.50	25.00	80.00

Adjunctive pieces

	Crystal, Pink	Green	Ritz Blue
Bowl, ruffled edge, 3 legs (console)	15.00	17.50	22.50
Candlesticks (pair), 3 styles	15.00	25.00	30.00
Hot apple cider set, 6 tumblers, metal tray and cover, wooden ball knob, burgundy and blue			75.00

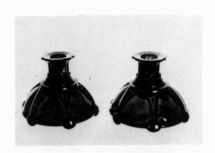

ROYAL RUBY*

Individual pieces	Deep Red
Plate, 9"	$3.50
Plate, 7 3/4"	2.50
Plate, 7"	2.00
Plate, 6 1/2"	1.50
Bowl, 7 1/2"	3.00
Bowl, 5 1/4"	2.50
Bowl, 4 1/4"	2.00
Cup	3.00
Saucer	2.00
Tumbler, footed, 2 1/2 oz.	4.50
Tumbler, 10 oz.	4.50
Tumbler, 5 oz.	3.50
Tumbler, 3 1/2 oz.	4.00
Sherbet	3.00

Serving pieces	
Plate, 13 3/4"	7.50
Bowl, 11 1/2"	12.50
Bowl, 8 1/2"	5.00
Bowl, oval, 8"	4.50
Pitcher, 3 qt.	20.00
Pitcher, 42 oz.	7.50
Pitcher, tilted, 3 qt.	8.50
Pitcher, tilted, 42 oz.	7.50
Sugar (2 styles)	4.00
Creamer (2 styles)	4.00
Punch set, bowl, base, 12 cups	40.00

*See color plate 22 in The Collector's Guide to Depression Glass.

Adjunctive pieces Deep Red

Flower basket, crystal frog, 5 1/2" dia. $5.50
Ivy bowl, 4" dia. 6.00
Candle glass, 2" 2.50

Note: Since this was a late pattern numerous giftware items were
 made in ruby glass.

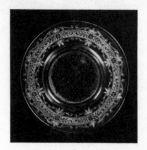

S PATTERN

Individual pieces	Topaz, Pink	Crystal, Crystal with Variety of Trims
Plate, grill, 10 1/2"	$3.00	$2.50
Plate, 9"	4.00	3.50
Plate, 8" (red)	3.00	3.00
Plate, 6" (Monax)	2.50	2.50
Bowl, 5 1/2"	3.00	3.00
Cup	4.00	4.00
Saucer	2.00	2.00
Tumbler, 9 oz.	4.50	4.00
Tumbler, 5 oz.	4.00	4.00
Sherbet	3.50	3.00

Serving pieces

	Topaz, Pink	Crystal, Crystal with Variety of Trims
Plate, 11"	22.50	18.50
Bowl, 8 1/2"	6.50	6.00
Pitcher, 80 oz., 8"	27.50	25.00
Pitcher, 80 oz., 7 1/2"	25.00	22.50
Sugar, footed, 3"	3.50	3.50
Creamer, footed, 3"	3.00	3.00
Creamer, thin blown, 2 3/4"	3.00	3.00

SANDWICH (ANCHOR HOCKING)

Individual pieces	Crystal	Amber	Dark Green
Plate, 9"	$2.00	$3.00	$4.00
Plate, 7"	1.50	2.50	
Plate (set, with punch cup), 9"	2.50		
Bowl, 7"	3.00		12.50
Bowl, 6 1/2"	2.50	5.00	
Bowl, 6"	2.00		12.50
Bowl, crimped edge, 5"	2.00		
Bowl, 5"	1.50	2.50	3.50
Cup	2.00	3.00	4.50
Saucer	2.00	2.50	3.50
Tumbler, footed, 9 1/2 oz.	3.00		
Tumbler, 9 oz.	2.00		3.00
Tumbler, 5 oz.	2.00		3.00
Sherbet, crimped edge	1.50		
Sherbet	2.50		
Cup, plate	1.50		2.50
Custard cup	1.50		2.50

Serving pieces	Crystal	Amber	Dark Green
Plate, 12"	3.50	7.50	
Bowl, oblong, 8 1/2"	3.00		
Bowl, 8"	3.00		12.50
Fruit bowl, 8"	3.50		7.50
Bowl, oval, 5 3/4"	2.50		
Sugar and cover	3.50		7.50
Creamer	2.50		6.50

Serving pieces (Cont.)	Crystal	Amber	Dark Green
Pitcher, ice lip, 2 qt.	$12.50		$22.50
Pitcher, ice lip, 36 oz.	17.50		27.50
Cookie jar and cover	15.00	$22.50	25.00
Butter dish and cover	15.00		

SANDWICH (INDIANA)

Individual pieces	Crystal	Pink, Green	Teal Blue, Ruby Red
Plate, 10 1/2"	$3.50	$4.50	$7.50
Plate, 8 1/2"	3.00	4.00	5.00
Plate, oval, 8"	5.00	6.00	7.50
Plate, 7"	3.00	3.50	
Plate, 6"	2.00	3.00	3.50
Bowl, hexagonal, 6"	2.50	4.50	
Bowl, 6"	2.00	2.50	
Bowl, 4 3/4"	2.00	3.00	
Cup	2.50	3.50	4.50
Saucer	1.50	2.50	3.50
Tumbler, footed, 12 oz.	5.00	7.50	
Tumbler, footed, 8 oz.	3.50	6.50	
Tumbler, footed, 3 oz.	3.50	5.50	
Goblet, 9 oz.	5.00	7.50	
Goblet, 3 oz.	3.50	5.50	
Sherbet	3.00	5.00	5.00

Serving pieces

Plate, 13"	5.50	7.50	
Bowl, 8 1/2"	5.00	7.50	12.50
Pitcher, 68 oz.	15.00	40.00	
Relish tray, 10 1/2"	3.00	4.50	

Serving pieces (Cont.)	Crystal	Pink, Green	Teal Blue, Ruby Red
Sandwich server, center post	$8.00	$12.50	
Sugar	3.50	5.50	
Creamer	3.50	5.50	
Sugar and cover	10.00	17.50	
Butter dish and cover	27.50	40.00	$70.00
Mayonnaise dish with ladle	5.50	7.50	
Wine decanter and stopper	27.50	40.00	
Diamond-shaped tray, sugar, creamer	5.50		17.50
Cruet, 6 oz.	7.50	27.50	40.00

Adjunctive pieces

	Crystal	Pink, Green	Teal Blue, Ruby Red
Console bowl, ruffled edge, 10"	7.50	17.50	
Console bowl, rolled edge, 9"	7.50	17.50	
Candlesticks (pair), 3 1/2"	5.50	7.50	
Candlesticks (pair), 7"	9.00	17.50	
Bridge ash tray set	3.50	4.50	
Powder box and cover	7.50	17.50	

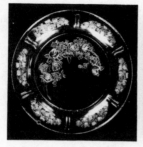
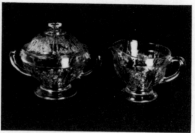

SHARON*

Individual pieces	Green	Pink	Amber
Plate, 9 1/4"	$4.00	$3.00	$3.00
Plate, 7 1/2"	3.00	2.50	2.50
Plate, 6"	2.50	2.00	2.00
Bowl, 7 1/2"	7.00	4.50	4.50
Bowl, 6"	5.50	3.00	3.00
Bowl, 5"	4.00	3.00	3.00
Bowl, cream soup, 5"	5.50	4.00	4.00
Cup	5.00	3.50	3.50
Saucer	3.00	2.00	2.00
Tumbler, footed, 15 oz.	30.00	10.00	10.00
Tumbler, 12 oz.	17.50	8.00	8.00
Tumbler, 9 oz.	15.00	7.00	7.00
Sherbet	5.00	3.00	3.00

Serving pieces			
Platter, 12 1/2"	10.00	7.50	7.50
Plate, footed, 11 1/2"	17.50	12.50	12.50
Bowl, oval, 9 1/2"	7.50	5.50	5.00
Pitcher, ice lip, 80 oz.	75.00	35.00	35.00
Pitcher, 80 oz.	70.00	30.00	30.00
Sugar with cover	8.50	6.00	6.00
Creamer	5.00	4.00	4.00
Candy jar and cover	40.00	15.00	14.00
Butter dish and cover	40.00	25.00	25.00
Salt and pepper	25.00	15.00	15.00
Cheese dish and cover	70.00	47.50	45.00
Cake plate (crystal) with metal cover	7.50		

*See color plates 10 and 13 in The Collector's Guide to Depression Glass.

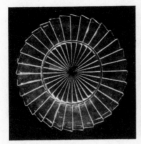
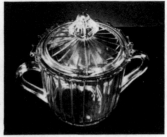

SIERRA

Individual pieces	Pink Crystal	Green
Plate, 9"	$3.50	$4.50
Bowl, 5 1/2"	2.00	3.00
Bowl, 4"	2.00	3.00
Cup	2.00	3.00
Saucer	1.50	2.00
Tumbler, 9 oz.	5.00	6.00

Serving pieces		
Platter, 11"	5.50	6.50
Serving tray, handled, 10"	5.50	6.50
Bowl, oval, 9 1/2"	6.50	7.50
Bowl, 8 1/2"	6.50	7.50
Pitcher, 32 oz.	15.00	27.50
Sugar and cover	4.50	5.50
Creamer	3.50	4.50
Butter dish and cover	25.00	30.00
Salt and pepper	12.50	15.00

SPIRAL

Individual pieces	Green
Plate, 8"	$2.50
Plate, 6"	1.50
Bowl, 4 3/4"	1.50
Cup	2.50
Saucer	1.50
Tumbler, 9 oz.	2.50
Sherbet	1.50

Serving pieces	
Plate, 9 1/2"	6.50
Bowl, 8"	3.50
Pitcher, 58 oz.	7.50
Sugar, 3"	3.00
Creamer, 3"	2.00
Sugar, 2 1/2"	3.00
Creamer, 2 1/2"	2.00
Preserve jar, lid (found with or without spoon hole)	5.50

Adjunctive pieces	
Ice bucket	3.50
Mixing bowl, 7"	3.00

STARLIGHT

Individual pieces	Crystal, Pink	Ritz Blue	White (opaque)
Plate, 9 1/2"	$1.50	$3.00	$2.50
Plate, 8 1/2"	1.00	2.50	2.00
Plate, 6"	1.00	2.00	1.75
Bowl, 4 3/4"	1.00	2.00	1.50
Cup	1.50	2.50	2.00
Saucer	1.00	2.00	1.50
Sherbet	3.00	4.00	3.50

Serving pieces			
Plate, 13 1/2"	3.50	5.00	4.00
Bowl, 11 1/2"	5.50	7.50	6.50
Bowl, 8 1/2"	2.50	5.00	3.50
Relish dish, 7"	2.50	4.50	3.00
Sugar	2.50	3.50	3.00
Creamer	2.50	3.50	3.00
Salt and pepper	5.00	7.50	6.00

STRAWBERRY, CHERRY

Individual pieces	Pink	Green	Crystal
Plate, 7 1/2"	$3.00	$4.00	$2.00
Plate, 6"	3.00	3.50	2.50
Bowl, 4"	2.50	3.00	2.00
Tumbler, 9 oz.	12.50	15.00	10.50
Sherbet	3.00	4.00	2.00

Serving pieces	Pink	Green	Crystal
Bowl, 7 1/2"	$5.50	$6.00	$4.00
Bowl, 6 1/2"	5.50	6.00	4.00
Pitcher, 7 3/4"	50.00	55.00	47.50
Sugar	5.50	6.50	4.50
Creamer	5.50	6.50	4.50
Sugar and cover, 5 1/2"	12.50	15.00	10.50
Creamer, 4 1/2"	6.50	7.50	5.50
Olive dish, 5"	5.00	6.00	4.00
Pickle dish, oval, 8 1/4"	4.00	5.00	3.00
Butter dish and cover	75.00	85.00	65.00
Comport, 5 3/4"	6.50	8.00	5.50

SUNFLOWER

Individual pieces	Green	Pink
Plate, 9"	$3.50	$2.50
Cup	4.00	3.00
Saucer	2.00	2.00
Tumbler, footed, 8 oz.	7.50	6.50

Serving pieces	Green	Pink
Cake plate, 10"	$4.50	$3.50
Sugar	4.50	3.50
Creamer	4.50	3.50

Adjunctive piece		
Ash tray, 5"	3.00	2.50

SWIRL (PETAL SWIRL)*

Individual pieces	Ultra-marine	Pink	Delfite
Plate, 9 1/4"	$4.50	$3.00	$5.00
Plate, 8"	3.50	2.50	3.00
Plate, 6 1/2"	3.00	2.00	2.50
Bowl, 5 1/4"	3.00	2.00	2.50
Lug soup dish	6.50	4.50	
Cup	4.50	3.50	6.00
Saucer	4.00	3.00	4.00
Tumbler, footed, 9 oz.	10.00	7.50	
Tumbler, 12 1/2 oz.	7.50	5.50	
Tumbler, 9 oz.	7.50	5.00	
Sherbet	4.50	2.50	

Serving pieces			
Plate, 12 1/2"	10.00	7.50	
Bowl, 10"	12.50	8.50	
Bowl, 9"	7.50	5.50	10.00
Sugar	5.00	4.00	10.00
Creamer	5.00	4.00	10.00

*See color plate and front jacket cover for The Collector's Guide to Depression Glass.

Serving pieces (Cont.)	Ultra-marine	Pink	Delfite
Butter dish and cover	$125.00	$47.50	
Candy dish and cover	22.50	17.50	
Candy dish, 3 legs	6.50	4.00	
Salt and pepper	17.50	15.00	

Adjunctive pieces

	Ultra-marine	Pink	Delfite
Console bowl, footed, 10 1/2"	12.50	8.00	
Candlesticks (pair)	15.00	12.50	$47.50
Ash tray, 5 1/2"	5.00	2.50	
Vase, 8 1/2"	10.00	6.50	
Vase, 6 1/2"	8.50	5.00	

SYLVAN (PARROT)*

Individual pieces	Green	Amber
Plate, grill, 10 1/2"	$5.00	$4.00
Plate, 9"	3.50	3.00
Plate, 7 1/2"	3.00	3.00
Plate, 6"	2.50	2.50
Bowl, 7"	5.00	4.50
Bowl, 5"	4.00	3.50
Cup	5.50	4.50
Saucer	3.50	3.50
Tumbler, footed, 5 3/4"	27.50	25.00
Tumbler, 12 oz.	22.50	20.00
Tumbler, 9 oz.	20.00	17.50
Sherbet, low	5.00	4.00
Sherbet, tall	40.00	35.00

*See color plate 7 in <u>The Collector's Guide to Depression Glass</u>.

Serving pieces	Green	Amber
Platter, 11"	$10.00	$7.50
Plate, square, 10 1/4"	7.00	6.00
Bowl, 10"	8.00	7.00
Bowl, 8 1/4"	7.50	6.00
Pitcher, 80 oz.	175.00	160.00
Sugar and cover	17.50	15.00
Creamer	6.00	5.00
Butter dish and cover	85.00	75.00
Preserve dish, 6 1/2"	6.50	5.50
Salt and pepper	47.50	47.50

Adjunctive piece

	Green	Amber
Hot plate coaster, 5"	55.00	55.00

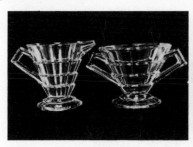 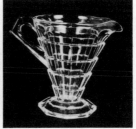

TEA ROOM

Individual pieces	Green	Pink	Crystal
Plate, 10 1/2"	$5.00	$4.00	$2.00
Plate, 8 1/4"	4.00	3.00	2.50
Plate, 6 1/2"	3.00	2.50	2.00
Cup	6.50	5.50	4.00
Saucer	3.00	2.50	2.00
Tumbler, 12 oz.	6.00	5.00	4.00
Tumbler, 11 oz.	5.00	4.00	4.00
Tumbler, 8 1/2 oz.	5.00	4.00	4.00
Tumbler, 6 oz.	4.50	3.50	3.50
Sherbet (at least 4 sizes, for fountain use)	5.00	4.00	4.00
Goblet, 9 oz.	7.50	6.50	5.00
Parfait	6.00	5.00	4.50

Serving pieces	Green	Pink	Crystal
Bowl, oval, 9 1/2"	$7.50	$6.50	$5.50
Bowl, deep, 8 1/2"	6.50	6.00	5.00
Bowl, 8 1/2"	6.50	6.00	5.00
Pitcher, 1/2 gal.	35.00	32.50	30.00
Sugar and cover	5.00	4.00	3.50
Creamer	4.00	3.50	3.00
Sugar and creamer, with tray	10.00	8.00	6.50
Divided relish dish	6.00	5.00	4.00
Sandwich server	7.50	7.00	6.50
Covered mustard	5.00	4.50	3.50
Ice bucket	12.50	10.00	10.00
Salt and pepper	14.00	13.00	12.50

Adjunctive pieces

	Green	Pink	Crystal
Candlesticks (pair)	17.50	15.00	14.00
Vase, ruffled edge, 9"	14.00	12.50	10.00
Lamp, 9"	25.00	22.50	20.00

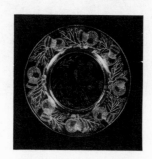

THISTLE

Individual pieces	Pink, Green
Plate, grill, 10 1/2"	$3.50
Plate, 9 1/4"	4.50
Plate, 8"	3.00
Plate, 6"	2.00
Bowl, 5 1/2"	3.50
Cup	4.00
Saucer	3.00
Sherbet	3.50

Serving pieces	Pink, Green
Plate, 13"	$17.50
Bowl, 9 1/2"	12.50
Bowl, 8 1/2"	10.50
Sugar	5.50
Creamer	5.50

THUMBPRINT (PEAR OPTIC)

Individual pieces	Green
Plate, 9 1/4"	$2.50
Plate, 8"	2.00
Plate, 6"	1.50
Bowl, 5"	1.25
Cup	2.50
Saucer	1.50
Tumbler, 4"	2.00
Sherbet	1.50

Serving pieces	
Bowl, 8"	4.00
Sugar	2.50
Creamer	2.50
Salt and pepper	7.50

TWISTED OPTIC

Individual pieces	Green	Pink	Amber	Blue
Plate, 8"	$2.50	$2.00	$2.00	$2.50
Plate, 7"	2.00	1.50	1.75	2.50
Plate, 6"	1.50	1.00	1.25	2.00
Bowl, 5"	3.00	2.50	2.75	3.25
Cup	3.50	3.00	3.00	3.50
Saucer	2.50	2.00	2.00	3.00
Tumbler, 4 1/2"	4.00	3.00	3.00	4.50
Sherbet	2.50	2.00	2.00	3.00
Coaster	2.00	1.50	1.50	2.50

Serving pieces	Green	Pink	Amber	Blue
Bowl, 8"	5.00	4.00	4.00	6.00
Sugar	5.00	3.50	4.00	5.00
Creamer	4.00	3.00	3.50	4.00
Pitcher	7.50	5.50	5.50	6.50
Candy jar and cover	10.00	8.00	8.00	10.00

Adjunctive pieces	Green	Pink	Amber	Blue
Console bowl, rolled edge, 12"	$7.50	$6.00	$6.00	$8.00
Candlesticks (pair)	7.50	6.00	6.00	8.00

VERNON

Individual pieces	Green	Yellow	Crystal
Plate, 8"	$5.00	$4.00	$3.00
Plate, 6"	3.00	2.50	2.00
Cup	3.50	3.00	2.50
Saucer	3.50	3.00	2.50
Tumbler, footed, 5"	3.00	2.50	2.00
Sherbet	3.00	2.50	2.00

Serving pieces			
Plate, 11"	7.50	6.50	5.00
Sugar	5.00	4.00	3.00
Creamer	5.00	4.00	3.00
Relish dish, 3 sections	7.50	6.50	5.00

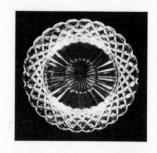

WATERFORD

Individual pieces	Pink	Crystal
Plate, 9 1/2"	$3.00	$2.00
Plate, 7"	2.50	1.50
Plate, 6"	2.25	1.50
Bowl, 5 1/4"	2.50	2.00
Bowl, 4 3/4"	2.25	2.00
Tumbler, footed, 10 oz.	5.50	4.50
Goblet, 6"	5.00	4.00

Individual pieces (Cont.)	Pink	Crystal
Goblet, 5 1/4"	$4.00	$3.50
Sherbet	3.50	2.50
Coaster	2.50	2.00

Serving pieces

	Pink	Crystal
Plate, 13 1/2"	7.50	5.00
Plate, 10 1/4"	5.00	3.50
Bowl, 8 1/4"	5.00	3.50
Pitcher, ice lip, 80 oz.	12.50	10.00
Pitcher, 42 oz.	7.50	6.50
Sugar and cover	5.00	4.00
Creamer	4.00	3.00
Butter dish and cover	17.50	15.00
Salt and pepper	5.00	3.50
Lazy Susan, 14"	7.50	6.50

Adjunctive piece

	Pink	Crystal
Ash tray	2.50	2.00

WINDSOR

Individual pieces	Pink	Green	Crystal
Plate, 9"	$3.00	$3.00	$2.50
Plate, 7"	2.50	2.50	2.00
Plate, 6"	2.25	2.25	1.50
Bowl, 5 1/2"	4.00	4.50	3.50
Bowl, 5"	2.50	2.50	2.00
Bowl, handled, 5"	4.00	4.00	3.50
Cup	3.50	3.50	3.00
Saucer	2.50	2.50	2.00
Tumbler, footed (crystal only), 7"	5.00	5.50	4.00
Tumbler, 12 oz.	6.50	6.50	5.00
Tumbler, 9 oz.	5.50	5.50	4.50
Tumbler, 5 oz.	5.00	5.25	4.00
Sherbet	4.00	4.00	3.00
Coaster	2.50	2.50	2.00

Serving pieces	Pink	Green	Crystal
Plate, 13 1/2"	$10.00	$12.50	$7.50
Platter, 11 1/2"	6.00	6.50	5.50
Relish platter, divided, 11 1/2"	6.00	6.50	5.50
Cake plate	7.50	7.50	6.50
Bowl, 13"	15.00	17.50	12.50
Bowl, 10 1/2"	12.50	12.50	10.00
Bowl, handled, 9 1/2"	7.50	7.50	6.00
Bowl, boat-shape, 11 3/4" long	15.00	17.50	12.50
Bowl, 8 1/2"	6.00	6.50	5.50
Bowl, with legs, 7"	5.00	5.00	4.50
Sandwich tray, handled, 10 1/4"	6.00	6.00	4.50
Serving tray, 15 1/2"	6.00	6.50	4.50
Serving tray, 13 1/2"	6.00	6.50	4.00
Butter dish and cover	22.50	25.00	17.50
Candy jar and cover	15.00	17.50	12.50
Cheese dish and cover	12.50	15.00	10.00
Relish set in metal holder	7.50	7.50	6.00
Pitcher, 52 oz.	15.00	15.00	12.50
Pitcher, 48 oz.	15.00	15.00	12.50
Pitcher, 16 1/2 oz.	12.50	12.50	9.00
Sugar and cover (2 styles)	5.00	5.00	4.00
Creamer (2 styles)	5.00	5.00	4.00
Salt and pepper	12.50	12.50	10.00

Adjunctive pieces

	Pink	Green	Crystal
Tray, 8 1/2" x 9 3/4"	6.50	6.50	5.50
Tray, 4" x 9"	5.00	5.00	3.50
Tray, 4" square	3.50	3.50	3.00
Candlesticks (pair)	15.00	17.50	12.50
Ash tray, 5 3/4"	3.00	3.00	2.50
Powder jar and cover	5.00	5.00	4.00

Section II
Kitchenware

CRISS CROSS PATTERN (HAZEL ATLAS)

	Ritz Blue	Pink, Green	Crystal
Refrigerator dish, 8" x 8"	$4.00	$3.00	$2.00
Refrigerator dish, 4" x 4"	3.50	2.50	1.50
Refrigerator dish, 4" x 8"	4.00	3.00	2.00
Butter dish, 1 lb. bar	22.50	15.00	10:00
Butter dish, 1/4 lb. bar	7.50	4.50	3.00
Mixing bowl, 10 1/2"	4.50	3.00	2.00
Mixing bowl, 9 1/2"	4.50	3.00	2.00
Mixing bowl, 8 1/2"	4.00	2.50	1.50
Mixing bowl, 7 1/2"	3.50	2.00	1.00
Mixing bowl, 6 1/2"	3.00	2.00	1.00
Reamer	5.00	3.00	2.00
Jug, ice lip, 54 oz.	7.50	5.00	3.50
Water bottle, 2 qt.	6.50	4.50	3.00
Water bottle, 1 qt.	5.00	4.00	2.50
Refrigerator dish, round, 6"	4.50	3.50	2.00
Sugar and cover	3.50	2.50	1.50
Creamer	3.00	2.00	1.00
Tumbler, 9 oz.	3.50	2.00	1.00

JADITE

Opaque green kitchenware made by McKee, Jeannette, and others.
Some of same pieces can also be found in Delfite (opaque blue).
Some storage pieces have black lettering.

Salt box, wood-hinged cover $8.50

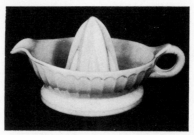

Reamer (average price, depending on style and color) 5.00

Range set salt and pepper, aluminum $3.50
5-piece range set: 4 shakers, drippings jar 5.50

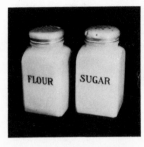
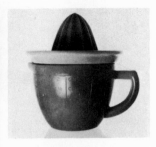

6-piece kitchen set: bowl, square refrigerator dish,
 reamer, measuring cup, 16 oz., 2 shakers 15.00
3-piece nested bowl set: 9 1/2", 7 1/2", 5 1/2" 5.00
Spice set: pepper, allspice, nutmeg, ginger 5.00

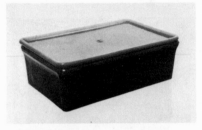

3-piece refrigerator storage set: large
 (9 3/4" x 4 3/4" x 5 1/2"); two smaller boxes
 that nest on top 5.50
3-piece refrigerator storage set: 3 stacked boxes,
 4 1/4" x 4 1/4" x 2 1/2" 4.50

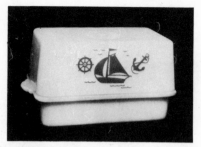

Butter dish, 1 lb. bar $5.00

RIBBED KITCHENWARE (JEANNETTE)

	Crystal	Ultra-marine (Teal Green)
Mixing bowl set: four bowls, nested. Largest bowl, 9 1/2"	$3.50	$6.50
3-piece range set: salt, pepper, drippings jar	2.50	5.00

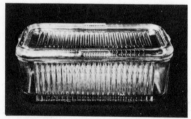

Stacked refrigerator set: one large box (4 1/2" x 2 3/4" x 8 3/4"), two others stack on top	3.50	6.00
Covered refrigerator bowls, round, 5 3/4" diameter, stack of 3	3.50	6.00

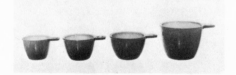

Nested measuring cups: largest, 1 cup; smallest, 1/4 cup; set of 4	2.50	7.50

	Crystal	Ultra-marine (Teal Green)
Nested measuring cups: 1 cup, 2/3 cup, 1/3 cup	$2.50	$7.50

Assorted odd pieces have been found in this pattern.

REAMERS

Lemon, lime, orange, and grapefruit squeezers have been found in
a great variety of colors and types of glass, typical of the
period between 1925 and 1940. Green, pink, and crystal are the
colors most commonly found. However, the opaque glass, and un-
usual colors such as black glass, are avidly sought by collectors.
A popular collector's item is one shown in the illustration on
page 136 of The Collector's Guide to Depression Glass. The
reamer labeled Sunkist was made in many different colors by
McKee Glass Company. Prices are higher for the opaque glass
reamers than for the transparent glass colors.

Two-piece reamer, measuring cup, and reamer insert,
 two shades of opaque green glass $25.00

 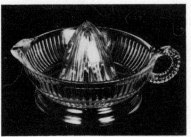

	Clear Glass, (many colors)	Opaque Glass (green, blue, cream, ivory)
Sunkist reamer	$6.50	$20.00
Reamer with embossing	5.00	17.50

	Clear Glass, (many colors)	Opaque Glass (green, blue, cream, ivory)
Reamer without embossing	$3.50	$12.50
Lime reamer (smaller, pointed cone)	3.50	10.50

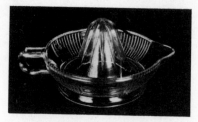

Grapefruit reamer	5.00	17.50

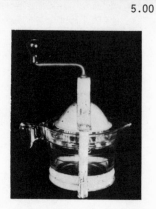

Metal and glass juice extractor	7.50	22.50

McKEE GLASSBAKE LINE

Numerous ovenproof glass dishes, pots, and pans were made during the depression glass period. Most of these were clear (crystal) glass and are still inexpensive. Bread pans, casseroles, pie plates, utility trays, etc., can be found at flea markets and are usually priced under a dollar. McKee made many of these items, as did Corning, Fry, and other companies.

Two collectible categories sought in the "glassbake" line are the fish set and the "Betty Jane Juvenile Set."

Seafood glassbake line	White Opal	Crystal
Master fish dish, wicker holder	$12.50	$8.00
Individual fish dish	4.50	3.00
Individual clamshell dish	4.50	3.00
Individual crabshell dish	4.50	3.00

Betty Jane Juvenile Set		
Covered casserole, round, 4 3/4"	4.50	
Pie plate, 5"	3.00	
Bread pan, 4 1/2" x 1 3/4"	3.00	
2 custard cups, 3 1/4", each	3.00	
5-piece set in original box	20.00	

VITROCK KITCHENWARE, HOCKING

White opaque unglazed glassware, usually embossed "Vitrock" on underside of dishes, made in 1935-1936. Some pieces are also available in jade green.

	Vitrock
Range set, 4 pieces	$22.50
Orange reamer	7.50
Orange reamer insert for measuring cup	5.00
Ash tray with match holder	2.50
Drippings jar and cover	3.50
Egg cup	2.50
Mixing bowl, 11 1/2"	5.50
Mixing bowl, 10 1/2"	5.00
Mixing bowl, 9 1/2"	4.50
Mixing bowl, 8 1/2"	4.00
Mixing bowl, 7 1/2"	3.50

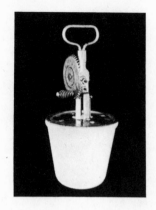

Mixing bowl, 6 1/2" $3.00
Mixing bowl with beaters 6.50

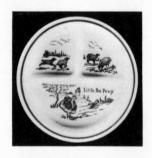

"Little Bo-Peep" divided feeding dish, 7 3/4" 17.50
Cereal dish, 5 1/4" 4.50
Mug, 7 oz. 4.50

Custard cup 2.00

ADDITIONAL PIECES

Refrigerator storage box and cover, vegetable motif,
8" x 8", 4" x 4", 4" x 8", pink, amber, green, crystal.
Made by Federal Glass Co. Set $5.00

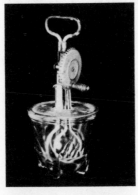

Beater bowl and beaters, green, crystal 6.50

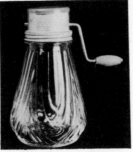

Nut grinder, draped pattern, green glass 4.50

Section III
Punch Sets

McKEE TOM AND JERRY SET

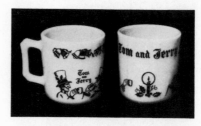

	White Opal	Custard
Mug, 7 oz.	$5.00	$5.00
Large punch bowl	17.50	20.00
Small punch bowl	15.00	17.50

HAZEL ATLAS TOM AND JERRY SET (DECORATED WITH HOLIDAY SCENES)

	White Opal
Mug, 7 oz.	$3.50
Punch bowl	12.50

ROYAL LACE PATTERN

	Ritz Blue	Burgundy
Punch set, metal stand, 6 tumblers, ladle	$75.00	$75.00

ROYAL RUBY

	Red
Punch bowl, 10"	$40.00
Punch cup	3.00
Base	5.00

SANDWICH PATTERN, ANCHOR HOCKING
Note: Many of these pieces are recent and not depression glass.

Punch bowl set, 14 pieces, plain ivory $30.00

Punch bowl set, 27 pieces (including cup hooks),
 plain ivory, white, or with gold trim 40.00

7-piece punch set, 3 qt. bowl 15.00

MODERNTONE, HAZEL ATLAS

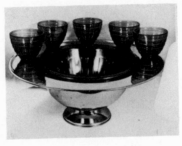

Ritz Blue

Punch bowl, metal bowl holder, bowl 9 1/2" dia.,
 12 cups, ladle $40.00

Section IV
Barware

HAZEL ATLAS SPORTSMAN SERIES

Golf motifs

	Cobalt Blue
Cocktail shaker, strainer lid	$22.50
Pitcher	20.00
Roly-poly glasses, 4 1/2 oz.	3.50
Tumbler, 12 oz.	4.00
Tumbler, 10 oz.	4.00
Tumbler, 8 oz.	3.50
Tumbler, 6 1/2 oz.	3.50
Tumbler, 5 oz.	3.50
Ice bucket	12.50

Hunt motifs

Shaker with strainer lid	22.50
Pitcher	20.00
Roly-poly glasses, 4 1/2 oz.	3.50
Tumbler, 12 oz.	4.00
Tumbler, 10 oz.	4.00
Tumbler, 8 oz.	3.50
Tumbler, 6 1/2 oz.	3.50
Ice bucket	12.50

Angel fish

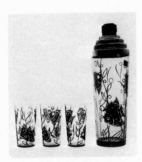

	Cobalt Blue	Crystal
Shaker, strainer lid	$22.50	$20.00
Pitcher	20.00	17.50
Roly-poly glasses, 4 1/2 oz.	3.50	3.50
Tumbler, 12 oz.	4.00	4.00
Tumbler, 11 oz.	4.00	4.00
Tumbler, 10 oz.	4.00	4.00
Tumbler, 8 oz.	4.00	4.00
Tumbler, 6 1/2 oz.	3.50	3.50
Tumbler, 5 oz.	3.50	3.50
Shot glass, 1 oz.	2.50	2.50

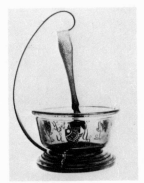

Ice bucket	12.50	10.00

Sailboat

	Cobalt	Amethyst
Shaker, strainer lid	$22.50	$25.00
Pitcher, ice lip	25.00	30.00
Roly-poly tumbler, 4 1/2 oz.	3.50	4.00
Tumbler, 4 1/2"	3.50	3.50
Tumbler, 5"	3.50	3.50
Tumbler, 12 oz.	4.00	4.50

Tumbler, 8 oz.	4.00	4.50
Tumbler, 6 1/2 oz.	3.50	3.50
Shot glass, 1 oz.	3.00	3.00
Punch cup	3.00	3.00

Windmills

Shaker, strainer lid	$17.50
Pitcher, roly-poly glasses	20.00
Tumbler, 12 oz.	4.00
Tumbler, 8 oz.	4.00
Tumbler, 6 1/2 oz.	3.50
Tumbler, 5 oz.	3.50
Shot glass, 1 oz.	3.00
Ice bucket	10.00

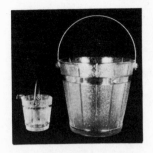

Old oaken bucket, bark finish $10.00
Matching ash tray 4.00

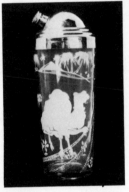

"Oasis" cocktail shaker 20.00

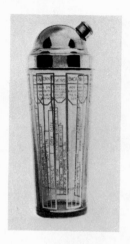

Recipe cocktail shaker, cobalt blue $20.00

Section V
Advertising and Promotional Items

Although many of the objects listed in other categories were of-
fered as premiums at various times, certain pieces of depression
glass were offered nationally by companies as promotional "gifts"
for their products. (Perhaps the best known of these are the
three Shirley Temple pieces in cobalt blue glass.)

Shirley Temple mug	$15.00
Shirley Temple pitcher	15.00
Shirley Temple cereal bowl	15.00
Sunkist reamer (black glass)	55.00
Sunkist orange bowl	70.00

Mixing bowl, Diamond Crystal shaker salt 7.50

Frigidaire ice bucket $4.00

Frigidaire water bottle 3.50
Ash tray (various advertisements, either in
 decal or embossed) 3.50

Ash tray with rubber tire rim 22.50

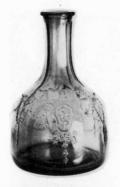

Whitehouse vinegar bottle (Cameo pattern) $14.00

Wesson Oil mayonnaise maker 7.50
Mission juice dispenser 35.00

Silex coffeemaker (used as package for
various products) $7.50

Spice jar with label, white opaque glass 2.50

About the Author

Marian Klamkin has written twelve books about her major field of interest, the small decorative arts. Perhaps her most successful book to date is <u>The Collector's Guide to Depression Glass</u>, the first comprehensive study of the depression glass collecting phenomenon. All of Marian Klamkin's books are illustrated with photographs by her husband, Charles Klamkin. The Klamkins recently collaborated on a new collector's book entitled <u>Wood Carvings: North American Folk Sculptures</u>. Marian Klamkin is a graduate of Clark University, where she was a news editor for the campus newspaper. She has recently written collector's books on boxes, Wedgewood, art nouveau, bottles, picture postcards, and marine antiques.